WILDLIFE PHOTOGRAPHER
OF THE YEAR

Portfolio 31

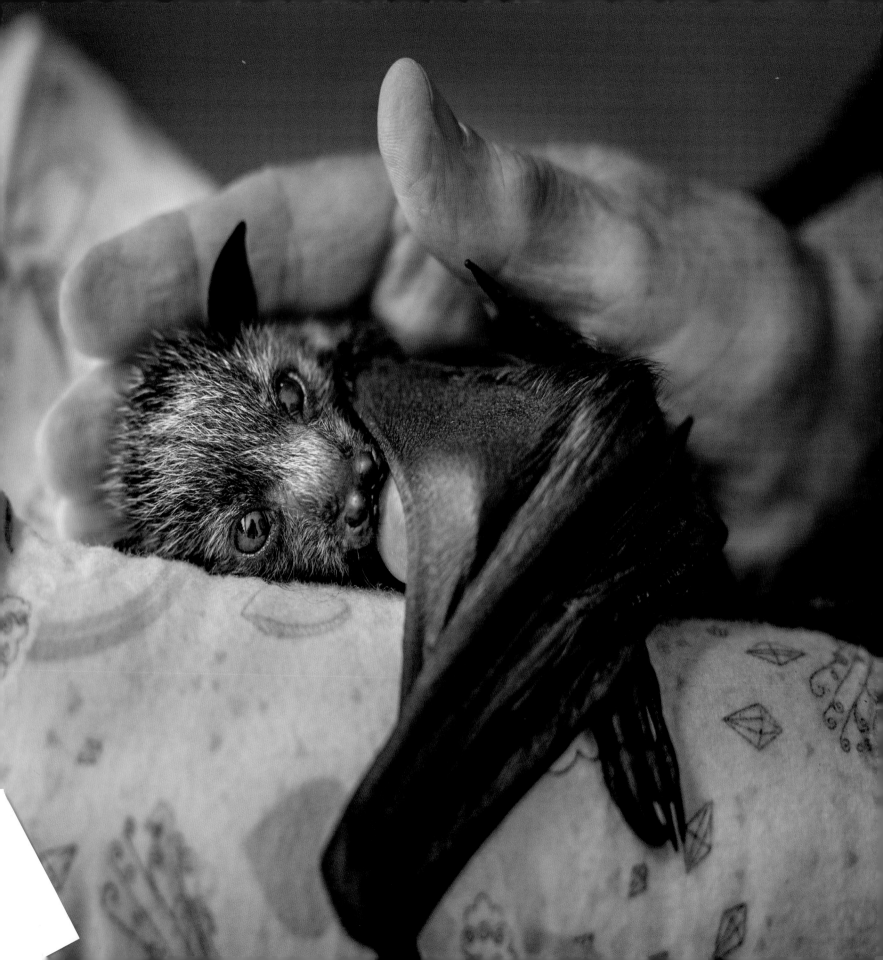

WILDLIFE PHOTOGRAPHER
OF THE YEAR

Portfolio 31

Published by the Natural History Museum, London

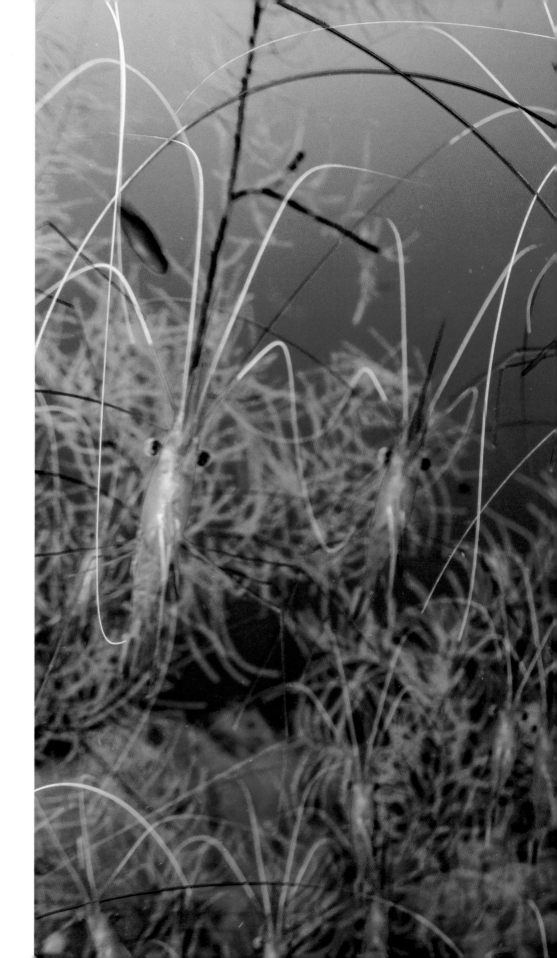

First published by the Natural History Museum,
Cromwell Road, London SW7 5BD
© The Trustees of the Natural History Museum,
London, 2021
Photography © the individual photographers 2021

ISBN 978 0 565 0 95208

A catalogue record for this book is available from
the British Library.

Editor Rosamund Kidman Cox
Designer Bobby Birchall, Bobby&Co Design
Writers R Kidman Cox, Anna Levin and Jane Wisbey
Image grading Stephen Johnson
　www.copyrightimage.com
Colour proofing Saxon Digital Services UK
Printing Printer Trento Sri, Italy

Right Deep feelers, by Laurent Ballesta
Previous page A caring hand, by Douglas Gimesy
Foreword page The great swim, by Buddhilini de Soyza
Competition page Grizzly leftovers, by Zack Clothier

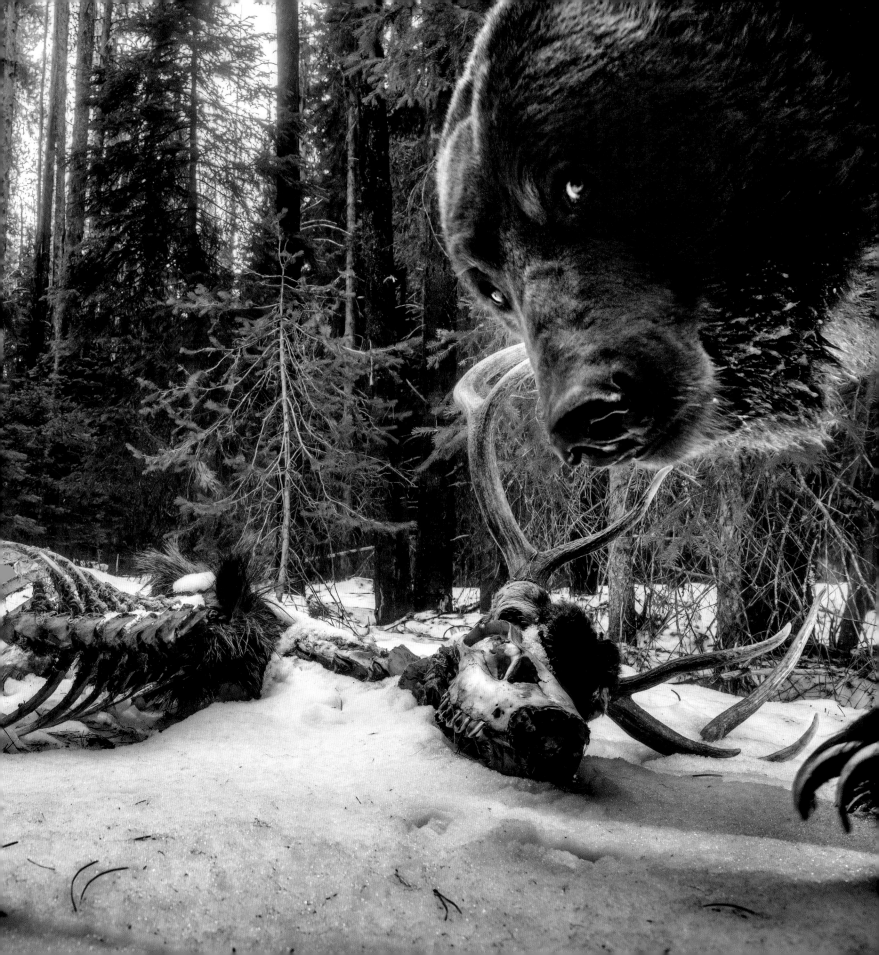

The Wildlife Photographer of the Year 2021

The grand-title winner of 2021 is Laurent Ballesta, whose picture was chosen from all the winners as the most striking and memorable.

Laurent Ballesta

FRANCE

An underwater photographer and biologist, Laurent is co-founder of the science and conservation organization Andromède Oceanologie. He has led major expeditions, all involving scientific mysteries, diving **challenges – including the deepest, longest dive in Antarctica – and unprecedented images, such as the first pictures of a living coelacanth taken by a diver and the night-hunting behaviour of packs of sharks. Laurent has 13 photographic books on undersea life to his name.**

Creation

A female camouflage grouper and her male entourage exit the milky cloud of eggs and sperm that fleetingly breaks the darkness. Moments before, she was resting on the seabed, the males watching and waiting. She suddenly darted up, trailing a profusion of eggs, and the males raced to follow. The dominant male – his status established over weeks of fighting – kept close. In an instant, the eggs were fertilized. All around, the scene was repeating, with fish shooting up like fireworks. Within half an hour, the annual spawning of camouflage groupers on Fakarava Atoll in French Polynesia was complete. It happens only around the full moon in July – when up to 20,000 of the fish gather in the narrow southern channel linking the lagoon with the ocean. Overfishing of such large aggregations elsewhere threaten this vulnerable species, but here the fish are protected within a UNESCO biosphere reserve. Every year, for five years, Laurent and his team returned, diving day and night so as not to miss the spawning. They were joined, after dark, by hundreds of grey reef sharks, hunting in packs, ripping the large groupers – typically 70 centimetres (27$^1/_2$ inches) long – to shreds. 'Sometimes the sharks bumped us so hard that we had bruises,' says Laurent, 'but they considered us obstacles, not prey.' Laurent's perfectly timed shot, captured the climactic moment, just before the spiralling fertilized eggs were swept away by strong currents and scattered in the open ocean.
(See also page 58.)

Nikon D5 + 17–35mm f2.8 lens; 1/200 sec at f11; ISO 1600; Seacam housing; Seacam strobes.

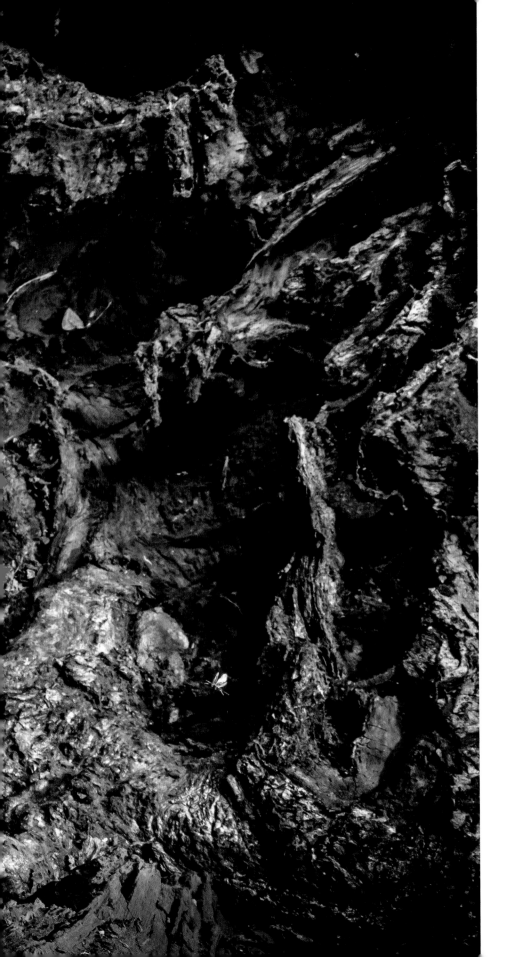

Ant pecker
Łukasz Gwiździel
POLAND

The discovery of a large hollow in an old oak tree, in woodland in northwest Poland, provided Łukasz with a natural stage set for a scene of foraging rodents or even roosting birds. It also gave him the first opportunity to use his new, ultra-wide-angle camera-trap system. Setting up his kit in the evening, carefully framing the arched hollow, he anticipated his first pictures being of rodents – 'there were clear traces of them inside.' But a few days later, to his delight he discovered that the star performer had been a female green woodpecker. The reason for her visit was the emergence on that one morning of swarms of black ants on their annual mass-mating flight. A large number had landed in the hollow, providing a banquet of the woodpecker's favourite food. Usually green woodpeckers hunt ants on the ground, probing nests with their beaks and catching the ants with their long, sticky, broad-tipped tongues. For two hours, the female came and went, feasting on the ants and probably delivering a crop-full to her chicks in a nest hole nearby. With his careful framing of the hollow and use of the wide angle, Łukasz was able to capture her, perfectly positioned, stretching to reach the bounty with her probing tongue.

Canon EOS RP + 16–35mm f4 lens at 16mm; 1/160 sec at f16; ISO 400; two Sony flashes; Yongnuo radio trigger; Camtraptions PIR motion sensor.

The all-purpose bill

Sebastián Di Doménico

COLOMBIA

Attracted by a commotion in trees surrounding the lodge in Palmari Nature Reserve, northwest Brazil, Sebastián discovered a white-throated toucan with an unexpected meal. While toucans are primarily fruit-eaters, most species opportunistically take insects, birds' eggs, nestlings, amphibians and small reptiles. And some, it seems, snatch bats. The bird was perched on a branch, gripping the struggling bat (probably taken from a roost in nearby palm trees) and whacking it against the tree. A white-throated toucan's bill – up to 60 centimetres (24 inches) long-– accounts for about a third of the bird's overall length. It may look heavy and unwieldy, but with external plates and a highly porous internal structure made of keratin, it is both strong and lightweight. The bill is adept at handling food and may also serve to attract mates and regulate body temperature (to cool down, toucans can increase blood flow to their bills). After an agonizing five minutes, the bat was dead, and the toucan switched trees to eat it, bit by bit, wings first. This particular bird was a regular visitor to the lodge; it had once been a victim of the pet trade but was rehabilitated in the reserve and reintroduced to the wild. Sebastián adjusted his camera for the low light, capturing the toucan's vibrant profile, as it overcame the helpless bat.

Nikon D500 + Sigma 150–600mm f5–6.3 lens at 390mm; 1/400 sec at f6; ISO 1600.

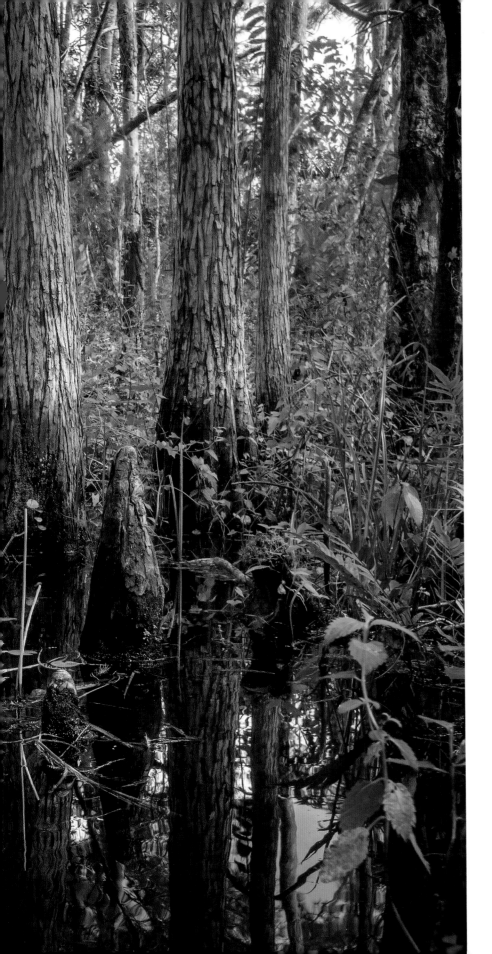

Drama at high water
Mac Stone

USA

Carrying a newborn cub, a raccoon moves through floodwater, almost certainly looking for a new, safer nesting place. Unseasonable heavy rain in late October (the end of the wet season) in Florida had caused a sudden spike in the water levels in Audubon's Corkscrew Swamp Sanctuary. This ancient Everglades swamp forest contains one of the world's largest remaining stands of old-growth bald cypress, providing valuable habitat for many species. These include raccoons, which like to nest in tree cavities. But in this particular area, the dominant trees are pond cypress, which are smaller and generally lack large cavities, driving raccoons to nest on the ground or in trees that might be more susceptible to storm damage. Raccoons typically have litters of three to five cubs, though over several days, the rescue of only this one cub was captured by Mac's camera trap, which itself only just escaped being flooded. It had been set up on an animal track through the wetland, with a carefully chosen backdrop of cypress trunks and 'knees' (woody projections growing up from the tree roots) intended to set the scene for a passing Florida panther or black bear. But when the camera was retrieved, the lucky surprise was finding this dramatic image of a flood rescue.

Canon EOS Rebel T3i + 10–20mm f3.5 lens at 20mm; 1/200 sec at f10; ISO 800; custom housing; Benro tripod; four Nikon SB-28 flashes; Camtraptions PIR motion sensor.

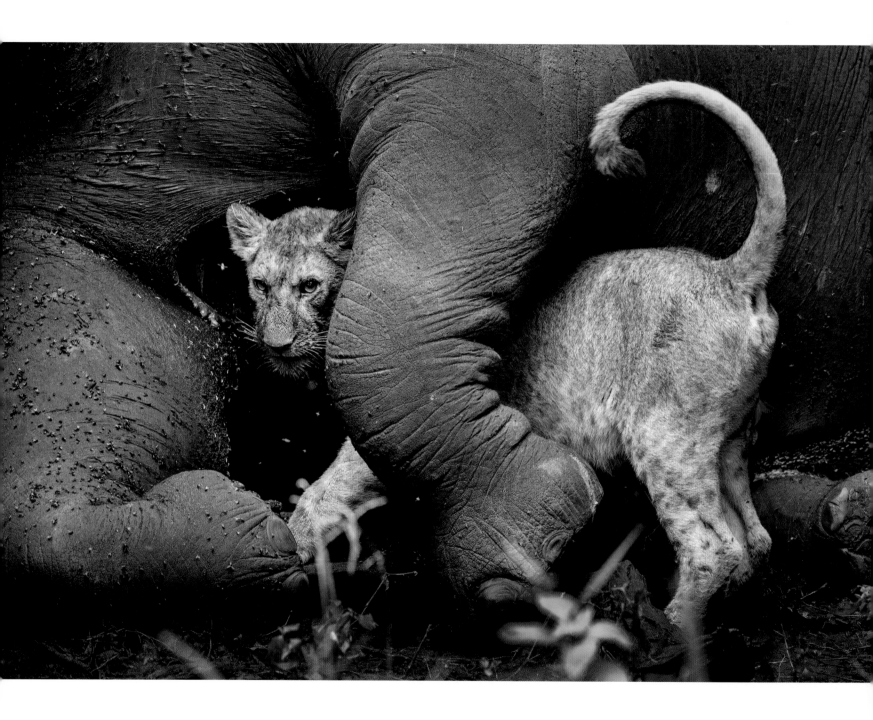

Belly to belly
Roie Galitz
ISRAEL

The swarming flies and lion cub's bloodied face give away the truth of this apparent embrace. And what the picture can't show is the stench. Roie had come across the full pride – two lions, six lionesses and their cubs – just after sunrise in Tanzania's Tarangire National Park. They were relaxing, stretched out on their backs, with full bellies. When one female cub disappeared behind a bush, Roie drove slowly around to discover the grim scene: the partly scavenged body of a decapitated female elephant, with the cub tucked under its leg to get at the meat. Lions rarely prey on elephants (and usually only when other prey is scarce). This individual had been sick and died naturally, according to rangers, who had removed its head to prevent theft of its tusks for the ivory trade. Lions readily scavenge any carcass they find: adult males eat before females, with cubs last (even when food runs short and they're starving to death while their mothers stay fed). This pride remained with the carcass for several days feasting on the bounty. Roie framed his shot to omit the gore and concentrate on the strange embrace and the cub's expressive posture.

Nikon D850 + 180–400mm f4 lens at 180mm; 1/200 sec at f5; ISO 1000.

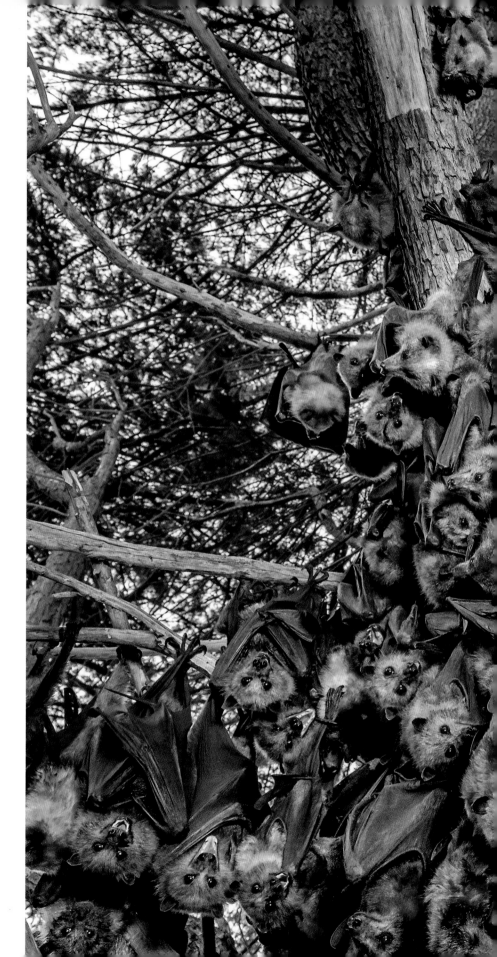

A deadly huddle
Douglas Gimesy

AUSTRALIA

Grey-headed flying-foxes collect en masse – their mouths agape, panting – having moved from their treetop roosts, desperate to escape the sun and hot wind and find a cooler spot. But such 'clumping' exacerbates their heat stress, and they often end up cascading to the ground, unable to take off and smothering each other. Such distressing events occur in Australia in extreme summers, such as that of 2019–20, when temperatures topping 43°C (110°F) gripped Melbourne for days. Coming just after their birthing season – when mothers were still nursing newborns – the bats were hit hard. In this particular colony, at Yarra Bend, 'Hundreds piled up at the base of trees, dead or dying from exhaustion or suffocation,' says Doug. Rescuers sprayed them with water and tried to save as many as possible, but more than 4,500 are estimated to have perished – about 10 per cent of the colony, including half the newborn pups. Similar tragedies occurred elsewhere in eastern Australia, where the species is endemic. Feeding on fruit, pollen and nectar, these large fruit bats – wings spanning more than a metre (3 feet) – play a key role in seed dispersal and tree pollination. They are threatened primarily by destruction and degradation of their forest habitat, but increasingly they face catastrophic heat-stress events, symptomatic of the global climate emergency.

Nikon D750 + 24–70mm f2.8 lens at 24mm; 1/250 sec at f9; ISO 2000.

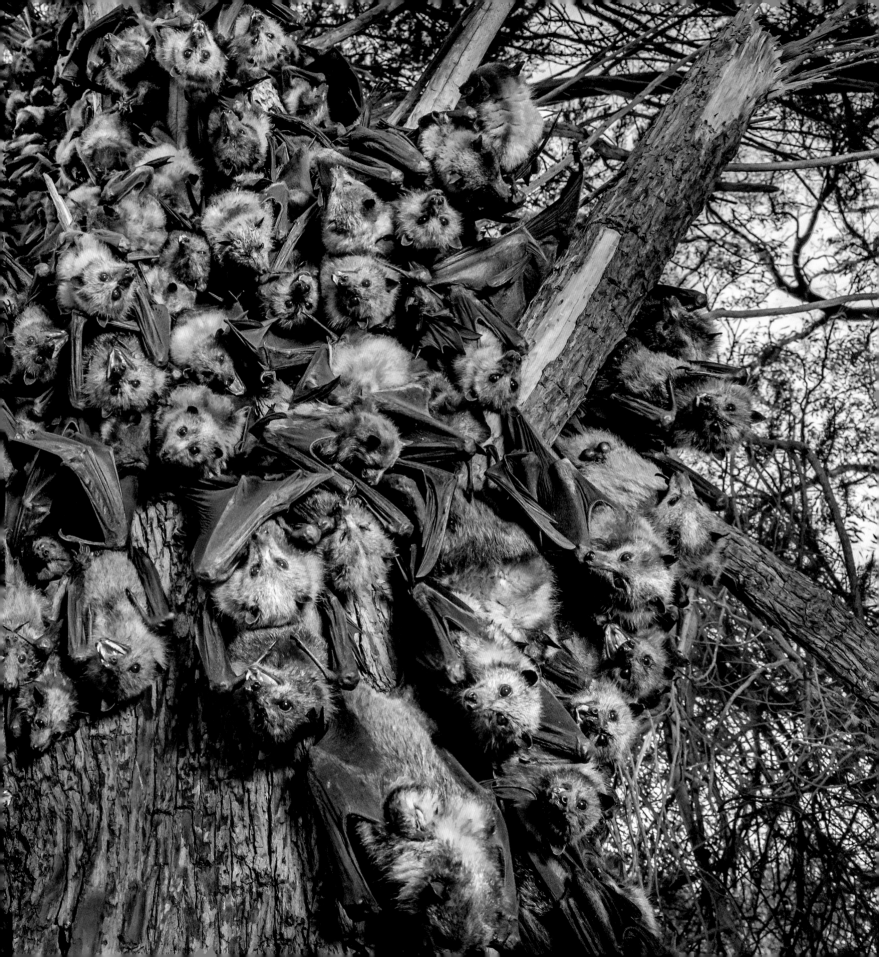

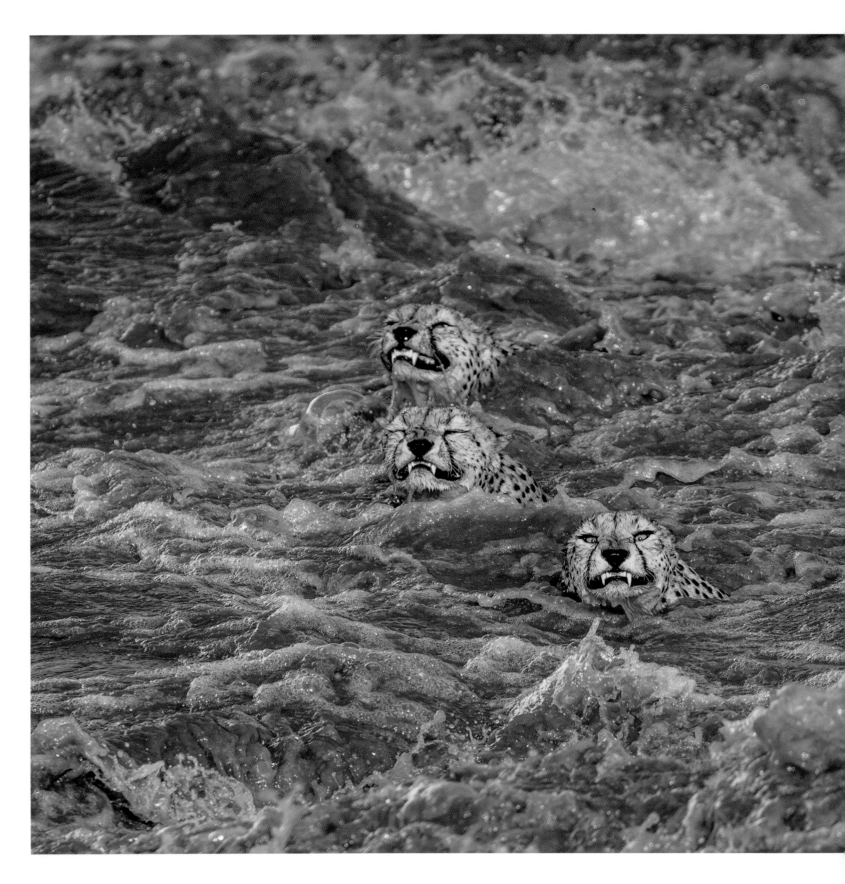

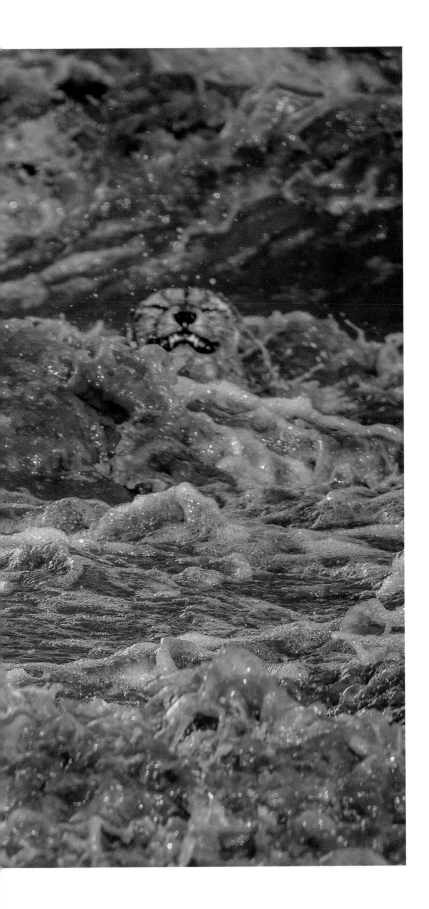

The great swim
Buddhilini de Soyza

SRI LANKA/AUSTRALIA

When the Tano Bora coalition of male cheetahs leapt into the raging Talek River in Kenya's Maasai Mara, Dilini feared they would not make it. Unseasonable, relentless rain (possibly linked to the changing climate) had, by January 2020, caused the worst flooding local elders had ever known. Cheetahs are strong (if not keen) swimmers, and with the prospect of more prey on the other side of the river, they were determined. Dilini followed them for hours from the opposite bank as they searched for a crossing point. Male cheetahs are mostly solitary, but sometimes they stay with their brothers or team up with unrelated males. The Tano Bora (Maasai for 'magnificent five') is an unusually large coalition, thought to comprise two pairs of brothers, joined later by a single male. 'A couple of times the lead cheetah waded into the river, only to turn back,' says Dilini. Calmer stretches – perhaps with a greater risk of lurking crocodiles – were spurned. 'Suddenly, the leader jumped in,' she says. Three followed, and then finally the fifth. Dilini watched them being swept away by the torrents, faces grimacing. Against her expectations and much to her relief, all five made it. They emerged onto the bank some 100 metres (330 feet) downstream and headed straight off to hunt.

Canon EOS 5D Mark IV + 100–400mm f4.5–5.6 lens at 400mm; 1/2000 sec at f5.6; ISO 640.

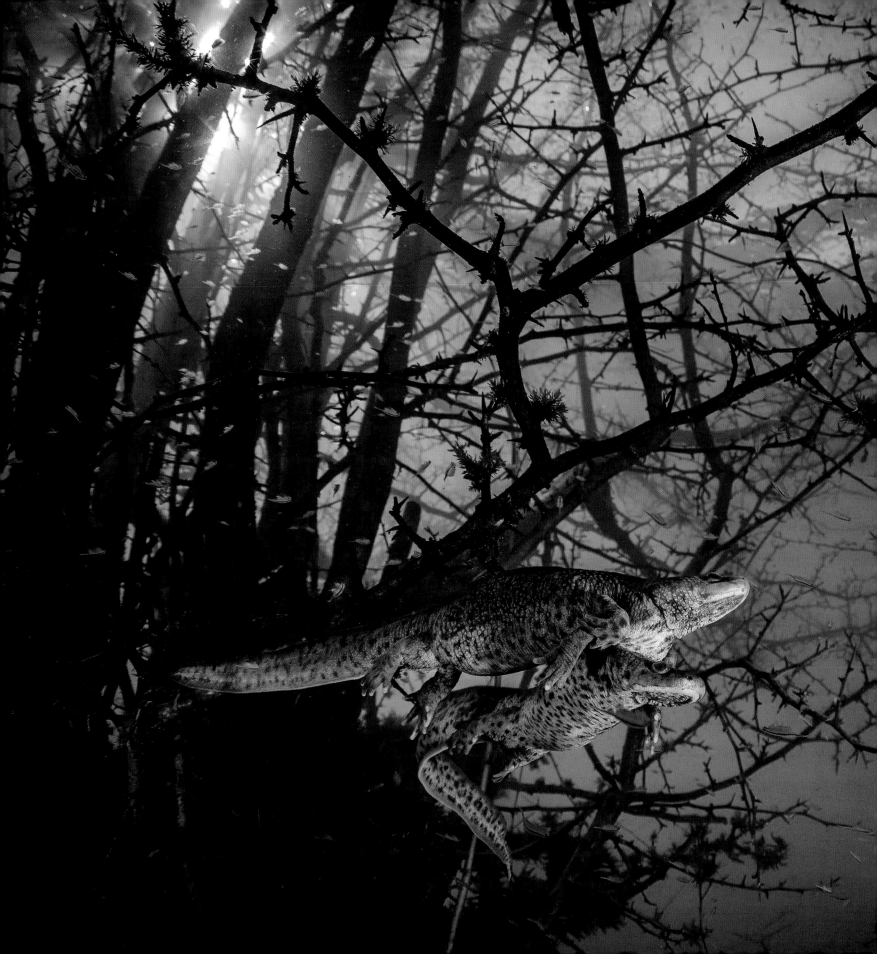

Behaviour: Amphibians and Reptiles

Where the giant newts breed
João Rodrigues
PORTUGAL

Taking João by surprise, a pair of courting sharp-ribbed salamanders, or newts, swam out of a thicket in the flooded forest, right in front of him, the male still grasping the female. The location was the huge seasonal lake in a valley in the Serras de Aire e Candeeiros Natural Park, central Portugal. Known as the 'Sea of Minde', it emerges only in winters of exceptionally heavy rainfall, when underground rivers running through the chalk massif of the Sierra de Aire overflow. João was on a mission to document Portugal's freshwater ecosystems – at a time when pollution, construction and introduced species are endangering most freshwater habitats – and this was his first chance in five years to dive the lake. It was a magical experience, he said. 'Swimming among the trees really did feel like flying.' Manoeuvring down through blackthorn branches, taking care not to disturb any sediment, he began trying to photograph the multitude of tiny fairy shrimps that, triggered by the water influx, had hatched out of the mud. When the salamanders appeared, he had just a split second to adjust his camera settings and take two pictures before they swam into the shadows. Found only on the Iberian Peninsula and in northern Morocco, sharp-ribbed salamanders are effectively giant newts, up to 30 centimetres (12 inches) long. They are named after their bizarre defence strategy of using their sharply pointed ribs as weapons, piercing their own skin and picking up poison secretions as they do so before jabbing them into an attacker's mouth or paws.

Canon EOS 5D Mark IV + Tokina 10–17mm f3.5–4.5 lens at 16mm: 1/200 sec at f13; ISO 320; Aquatica housing; 2x INON Z-330 flashes.

Flashy fighters

Hitesh Oberoi

INDIA

Displaying their dazzling colours like battle flags and leaping side-on, two male Deccan fan-throated lizards size up as a prelude to a fight. In the hills of southern Maharashtra, India, these lizards use rocks to gain height when proclaiming their territory and advertising their virility – the healthier the lizard, the brighter the colours. Found only on the Indian subcontinent, fan-throated lizards are adapted to hot, dry environments. At least 15 species are found in India, and at up to 7 centimetres ($2^3/_4$ inches) in body length, the male of this species is among the largest. It also has the most impressive blue, black and orange dewlap – the loose flap on its throat, which extends down to its middle and can be opened like a fan to signal aggression and so warn off rivals as well as woo females. Hitesh was excited to discover these lizards in the hills above his home city of Ahmednagar, and for more than 40 days in summer he visited daily, enduring many hours in temperatures of up to 42°C (108°F) to find and watch them. This is the very first fight he witnessed, when one male began to expand his territory and encountered another male guarding his own. They fought for more than 30 minutes, leaping and clashing in the air and biting each other viciously, all at lightning speed. Rival males can fight until death, unless – as happened in this instance – one eventually backs off.

Canon 7D Mark II + 400mm f5.6 lens; 1/2000 sec at f8; ISO 400.

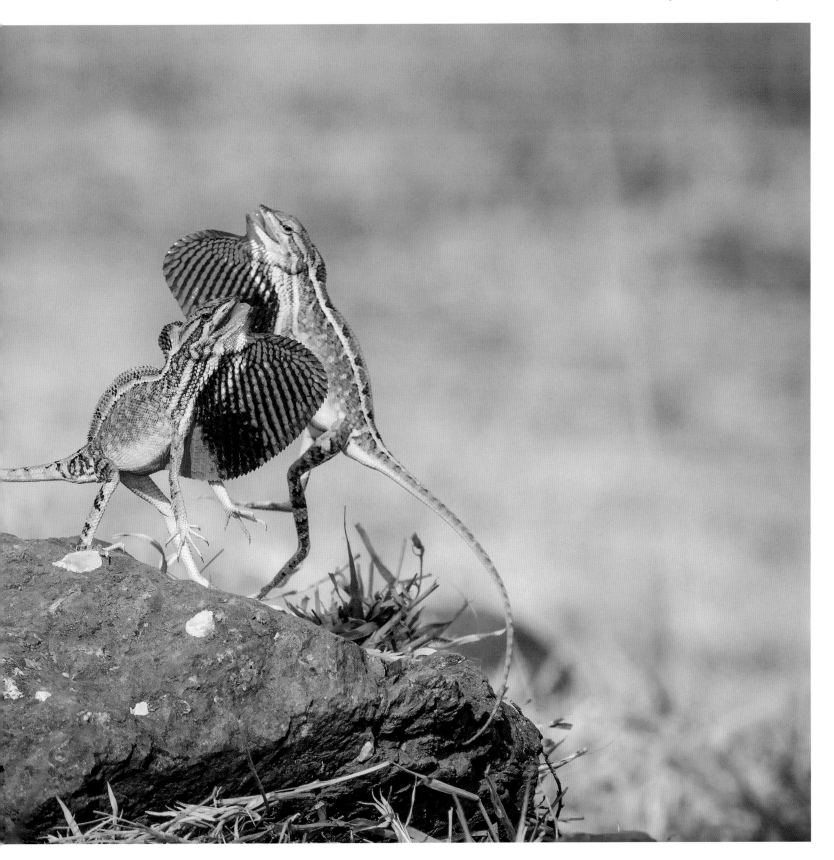

The gripping end

Wei Fu

THAILAND

Clutched in the coils of a golden tree snake, a red-spotted tokay gecko stays clamped onto its attacker's head in a last attempt at defence. Named for their *to-kay* call, tokay geckos are large – up to 40 centimetres (16 inches) long – feisty and have powerful jaws. But they are also a favourite prey of the golden tree snake. This snake, common in the lowland forests of South and Southeast Asia, also hunts lizards, amphibians, birds and even bats, and is one of five snakes that can 'fly', expanding its ribs and flattening its body to glide from branch to branch. Wei was photographing birds at a park near his home in Bangkok, Thailand, when his attention was caught by the loud croaking and hissing warnings of the gecko. It was being approached by the golden tree snake, coiled on a branch above and slowly letting itself down. As the snake struck, injecting its venom, the gecko turned and clamped onto the snake's upper jaw. Wei watched as they wrestled, but within minutes, the snake had dislodged the gecko, coiled tightly around it and was squeezing it to death. While still hanging from the loop of its tail, the slender snake then began the laborious process of swallowing the gecko whole.

Canon EOS 7 Mark II + Tamron SP 150–600mm f5–6.3 G2 lens; 1/800 sec at f7.1; ISO 1000.

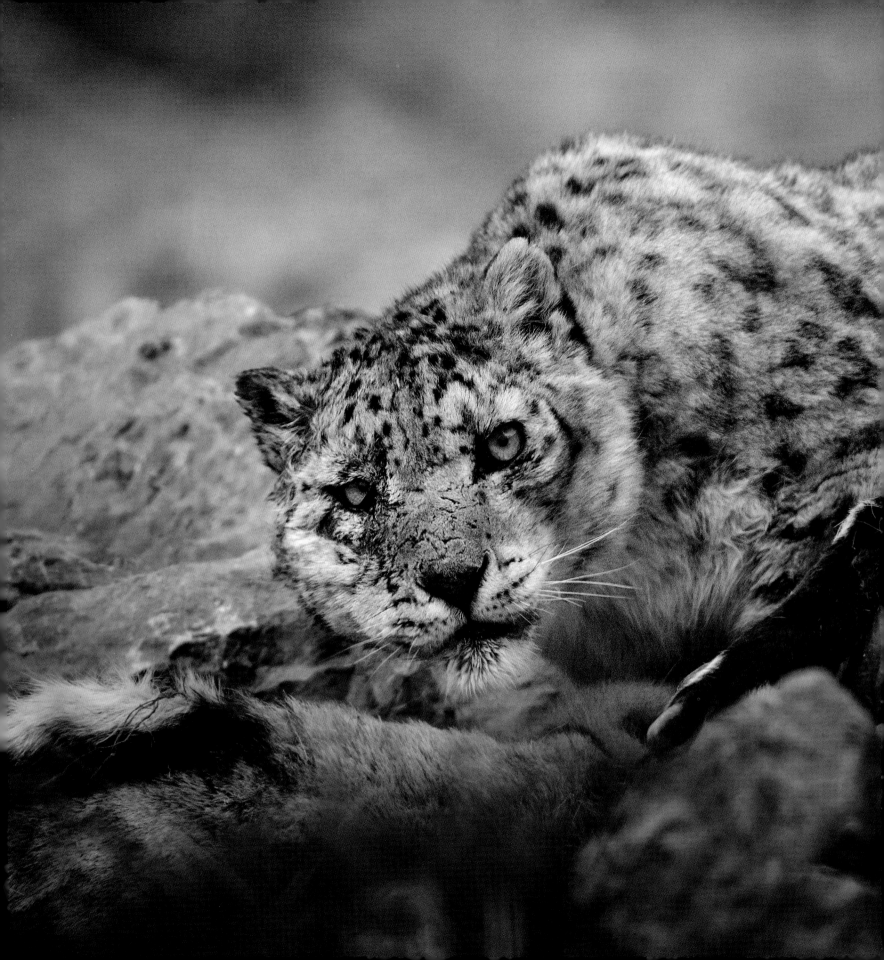

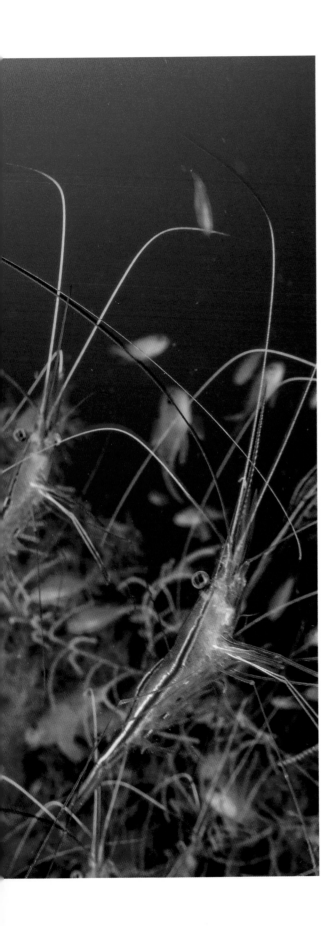

Deep feelers

Laurent Ballesta

FRANCE

In deep water off the French Mediterranean coast, among cold-water black coral, Laurent came across a surreal sight – a vibrant community of thousands of narwhal shrimps. Their legs weren't touching, but their exceptionally long, highly mobile outer antennae were. It appeared that each shrimp was in touch with its neighbours and that, potentially, signals were being sent across a far-reaching network. Research suggests that such contact is central to the shrimps' social behaviour, in pairing and competition. In such deep water (78 metres down – 256 feet), Laurent's air supply included helium (to cut back on nitrogen absorbed), which enabled him to stay at depth longer, stalk the shrimps and compose an image at close quarters. Against the deep-blue of the open water, floating among the feathery black coral (white when living), the translucent narwhal shrimps looked exceptionally beautiful, with their red and white stripes, long orange legs and sweeping antennae. Between a shrimp's bulbous stalked eyes, flanked by two pairs of antennae, is a beak-like serrated rostrum that extended well beyond its 10-centimetre (4-inch) bodies. Narwhal shrimps are normally nocturnal and often burrow in mud or sand or hide among rocks or in caves in the day, which is where Laurent was more used to seeing them. They are also fished commercially. When shrimp-fishing involves bottom-trawling over such deep-water locations, it destroys the slow-growing coral forests as well as their communities.

Nikon D5 + 15–30mm f2.8 lens at 30mm; 1/40 sec at f20; ISO 1600; Seacam housing; Seacam strobes.

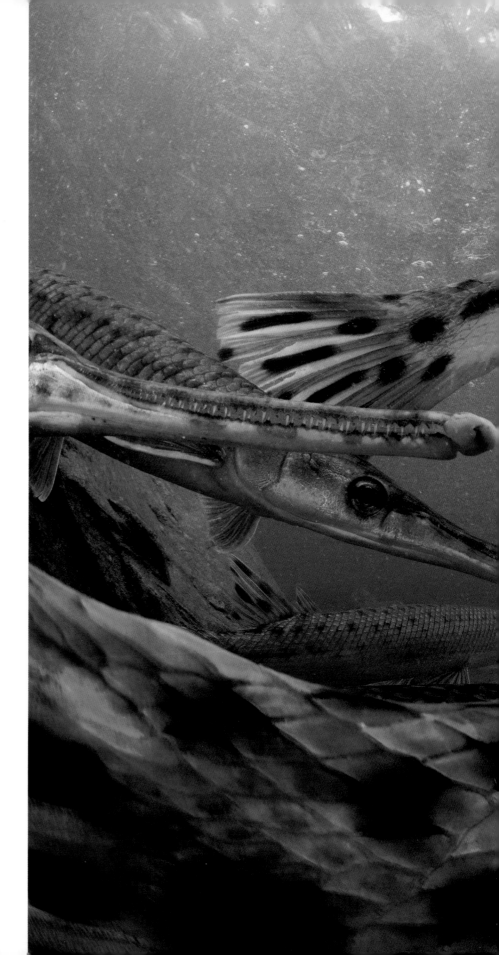

River dance
David Herasimtschuk
USA

As the multitude of longnose gar swished excitedly over the bed of Citico Creek, in Tennessee, USA, David lay quietly in the water more than 6 metres (20 feet) away, so as not to disturb them. These reptilian-looking fish are about a metre long (more than 3 feet), with hard, diamond-shaped scales and snapping jaws armed with sharp teeth. They are also surprisingly shy. In spring, hundreds of them migrate up rivers to spawn in small, fast-flowing creeks. David positioned his camera by a small depression in the bedrock, where gravel had accumulated. Females were heading there to release their sticky, greenish eggs – some 30,000 per fish (the record is 77,000) – closely followed by numerous males, hoping to fertilize them. Poisonous to birds and mammals, the eggs are left untended by the parents (though they are sometimes laid in nests of smallmouth bass, where males protect the developing gar as well as their own offspring). David watched closely through his mask, fingers poised on the fishing line he had connected to the shutter release. 'I had an idea for framing,' he says, 'so when the fish swam into the right areas, I pulled the line to trigger the camera.' His concept conveys the commotion and thrill of the spawning congregation, with a jigsaw arrangement of parts of gars and with the first eggs scattered about like pearls.

Sony ILCE-7RM3 + Canon 8–15mm f4 lens at 15mm; 1/125 sec at f20; ISO 1250; Nauticam housing; two INON Z-240 strobes.

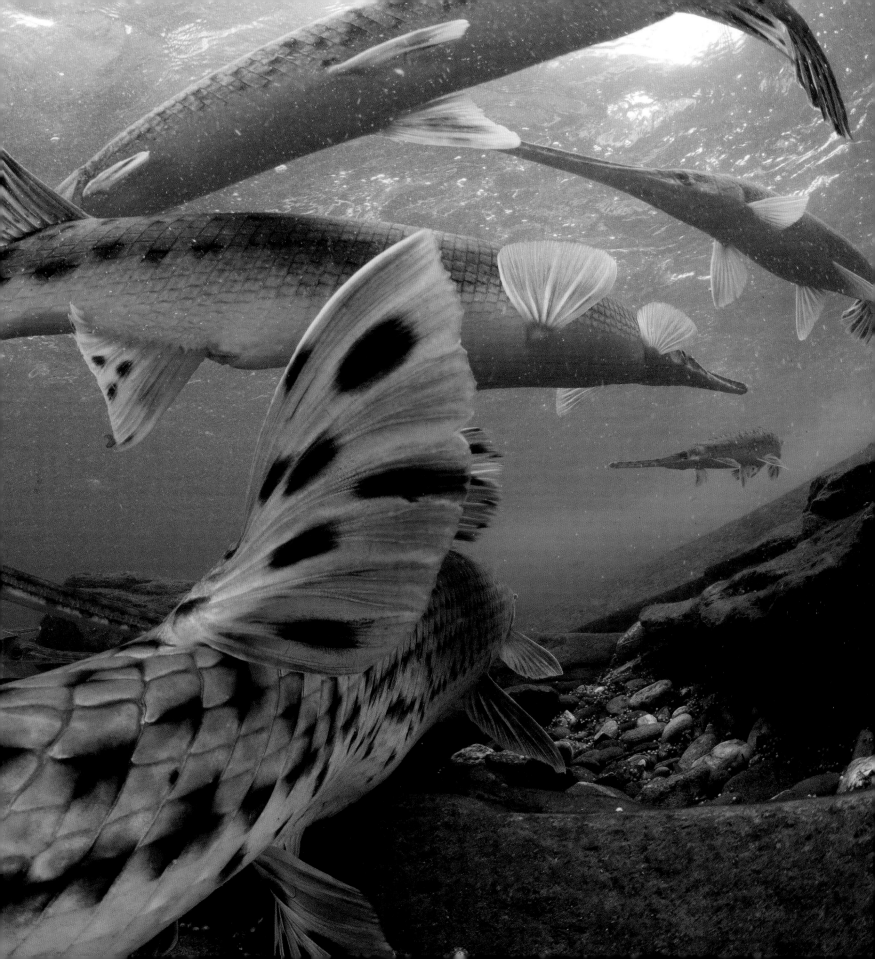

Portfolio Award

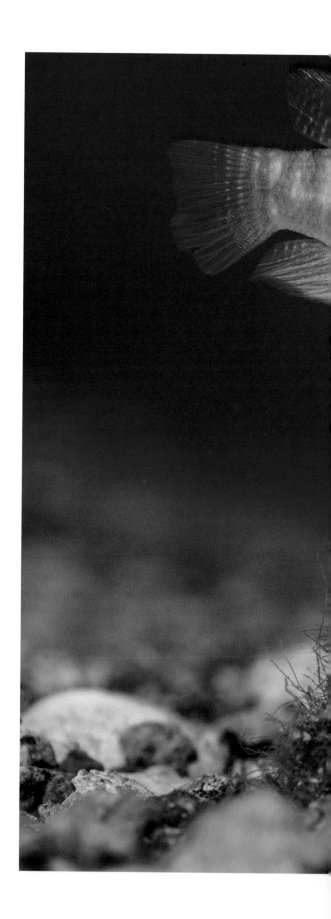

Angel Fitor
SPAIN

CICHLIDS OF PLANET TANGANYIKA

This portfolio is about the wondrous fish in the oldest of the East African Great Lakes, Lake Tanganyika. Here in this deep, vast, isolated body of water, cichlid fish have evolved into more than 240 different shapes, sizes and behaviours to fill every kind of niche. Angel has been studying cichlids for two decades, and despite the difficulties and dangers of diving in the lake, he has photographed much of their extraordinary behaviour. But in addition to serious pollution, including soil run-off from deforestation, agrochemical run-off and sewage, the ornamental-fish trade is uncontrolled, driving some populations towards extinction. So the exact locations where he has taken his pictures have been kept secret.

Face-off

Two male brevis shell-dweller cichlids go jaw to jaw, competing for ownership of an old snail shell and its new occupant – a female, who has chosen it for her egg-laying and nursery needs. The male in the top position is guarding both the shell and his mating rights; the lower one is making a bold takeover attempt. Like virtually all 241 known species of cichlid, the brevis shell-dweller is found only in Lake Tanganyika. Shell nurseries are its speciality. The females have evolved to be a couple of centimetres smaller than the males but just the right size (about 2.5 centimetres long – 1 inch) to fit inside the empty shells of a particular snail – also found only in Lake Tanganyika. The species' success is tied to those particular shells, making an empty one worth fighting for. Over three weeks Angel monitored the lake bed looking for disputes over shells. Competing males are capable of hurting each other, but the biting and pushing lasts only until the weaker one gives way. In this case, the struggle was over in seconds but lasted just long enough for Angel to get his winning shot – his reward for several six-hour dives sitting on the sandy bottom, keeping watch on the shell.

Nikon D800 + Sigma APO Macro 150mm f2.8 lens; 1/200 at f9; ISO 200; Anthis Nexus housing; Retra strobes.

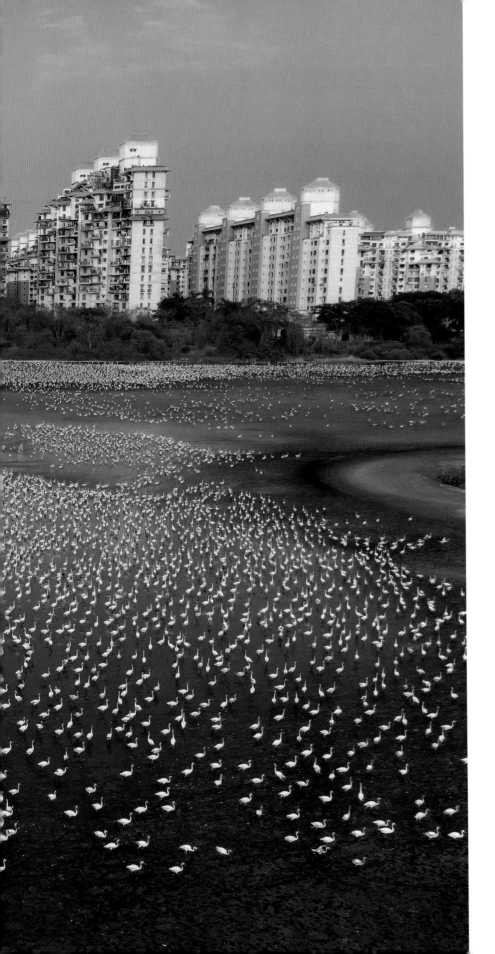

Flamingo outlook
Nayan Khanolkar

INDIA

On the west coast of India, on an estuarine creek bordering Navi Mumbai (New Bombay), is Talawe wetland, sandwiched between high-rises on one side and mangroves on the other. It provides a haven for birds and a beautiful vista for humans. When the lesser and greater flamingos arrive in December, from their breeding grounds in Gujarat, northwestern India, the water shimmers pink until they depart the following June. Nayan captured the spectacle with his drone in 2020 but says it isn't always this eye-catching. Reduced human activity – as a result of the Covid-19 lockdown – meant record numbers of birds and exceptionally clear air. 'I have never seen such blue skies in Mumbai,' he says. The gathering of flamingos is also tuned to the tides. The birds move close to the city only during high water, when the mangrove creeks are too flooded for them to feed. Their specialized bills filter blue-green algae and crustaceans, which give them their pink colour. Talawe is one of few wetlands in the area to have escaped the urban sprawl. But it is now threatened by a golf-course development, which will displace the flamingos and other birds, many of them migrants, dependent on this wetland for stopovers. Nayan monitored the tide tables, watching for the coincidence of high tide with the golden sunset hour until, one evening, it all came together, when the water level rose and thousands of flamingos moved in from the mangroves. In the soft sunset glow, he captured the birds and their high-rise neighbours against the clear blue sky.

DJI Mavic 2 Pro + Hasselblad L1D-20c + 28mm f2.8 lens; 1/60 sec at f4.5; ISO 100.

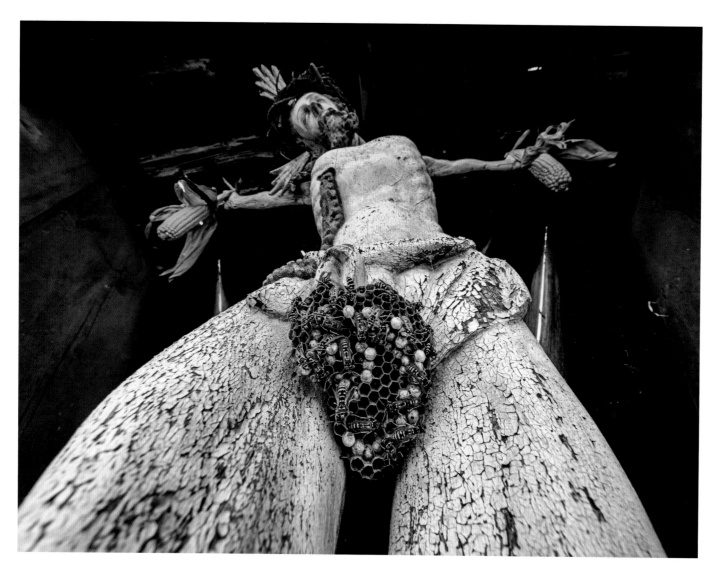

Spot of bother
Georg Kantioler

ITALY

A tip-off alerted Georg to this delicate situation. European paper wasps often nest on artificial structures. In this case, the queen had chosen to start her colony on a traditional wayside shrine in South Tyrol, northeastern Italy. It was carved in wood and decorated with corn cobs in thanks for the harvest. The wasps' skilfully crafted cluster of hexagonal cells were made from wood pulp mixed with saliva, and the whole nest was left without an outer casing. The queen lays her eggs in the cells and is helped by the workers – up to 15 millimetres (half an inch) long – to provision her offspring with chewed-up insects, especially caterpillars. When ready to pupate, the larvae cap their cells with silk. 'The wasps defended their home fiercely,' says Georg, 'I had to move very slowly and wrap up to avoid too many stings.' By photographing in the early morning, when the wasps were most docile, he was able to approach with a wide angle for maximum impact.

Canon EOS 5D Mark IV + Sigma 12–24mm f4 lens at 12mm; 1/40 sec at f16; ISO 1000.

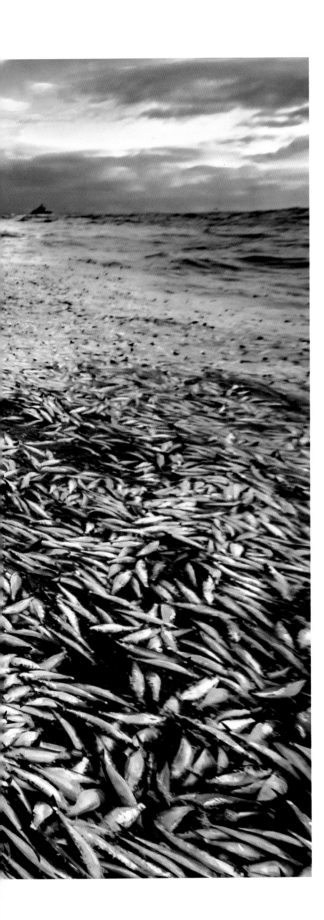

Net loss
Audun Rikardsen
NORWAY

In the wake of a fishing boat, a slick of dead and dying herrings covers the surface of the sea off the coast of Norway. The boat had caught too many fish, and when the encircling wall of the purse-seine net was closed and winched up, it broke, releasing tons of crushed and suffocated animals. Audun was on board a Norwegian coastguard vessel, on a project to satellite-tag killer whales. The whales follow the migrating herrings and are frequently found alongside fishing boats, where they feed on fish that leak out of the nets. For the Norwegian coastguard – responsible for surveillance of the fishing fleet – the spectacle of carnage and waste was effectively a crime scene. So Audun's photographs became the visual evidence in a court case that resulted in a conviction and fine for the owner of the boat. Overfishing is one of the biggest threats to ocean ecosystems, and according to the UN Food and Agriculture Organization, more than 60 per cent of fisheries today are either 'fully fished' or collapsed, and almost 30 per cent are at their limit ('overfished'). Norwegian spring-spawning herring – part of the Atlantic herring population complex – was in the nineteenth century the most commercially fished fish population in the North Atlantic, but by the end of the 1960s, it had been fished almost to extinction. This is regarded as a classic example of how a combination of bad management, little knowledge and greed can have a devastating and sometimes permanent effect, not only on the species itself but on the whole ecosystem. The Atlantic herring came close to extinction, and it took 20 years and a near-ban on fishing for the populations to recover, though it is still considered vulnerable to overfishing. The recovery of the herring has been followed by an increase in the numbers of their predators, such as killer whales, but it is a recovery that needs continued monitoring of herring numbers and fisheries, as Audun's picture shows.

Canon EOS-1D X Mark II + 14mm f2.8 lens; 1/320 sec at f13 (-0.33 e/v); ISO 1600.

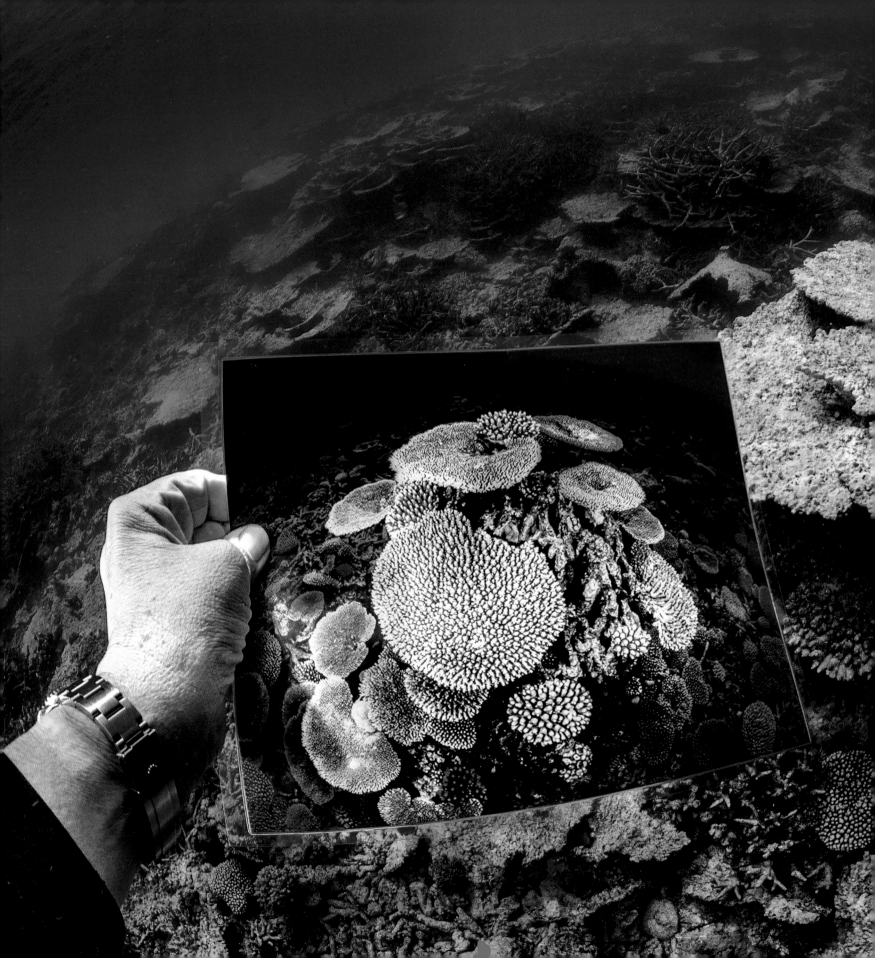

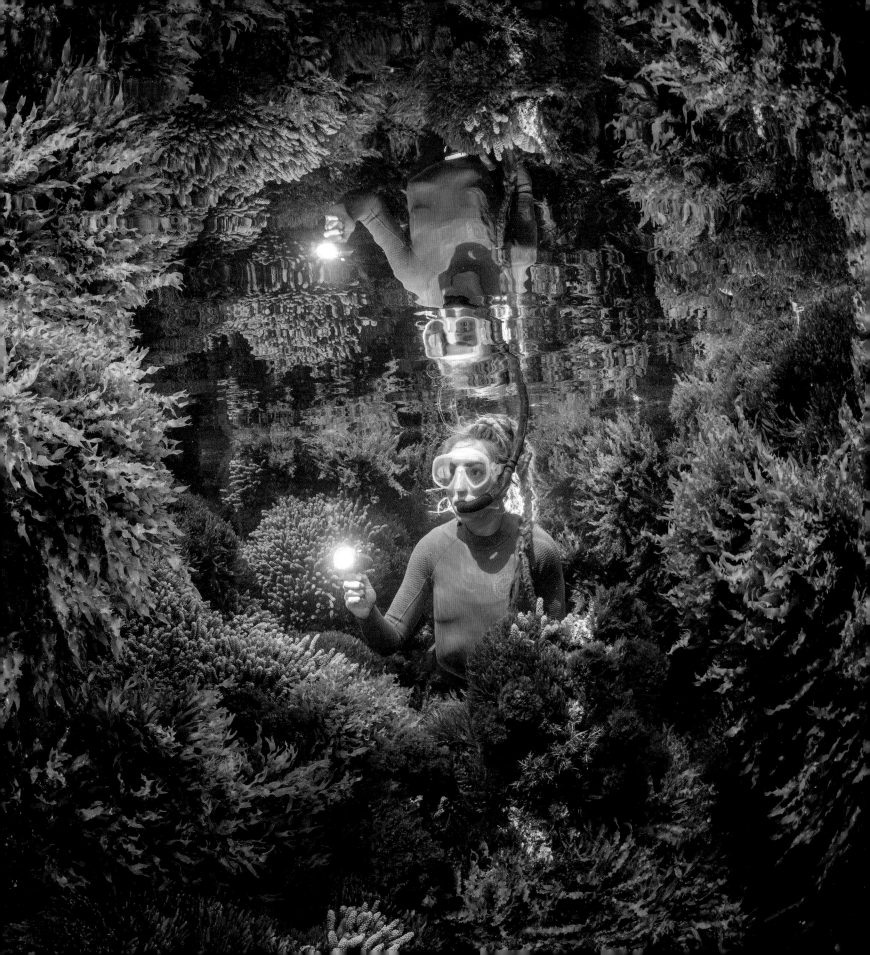

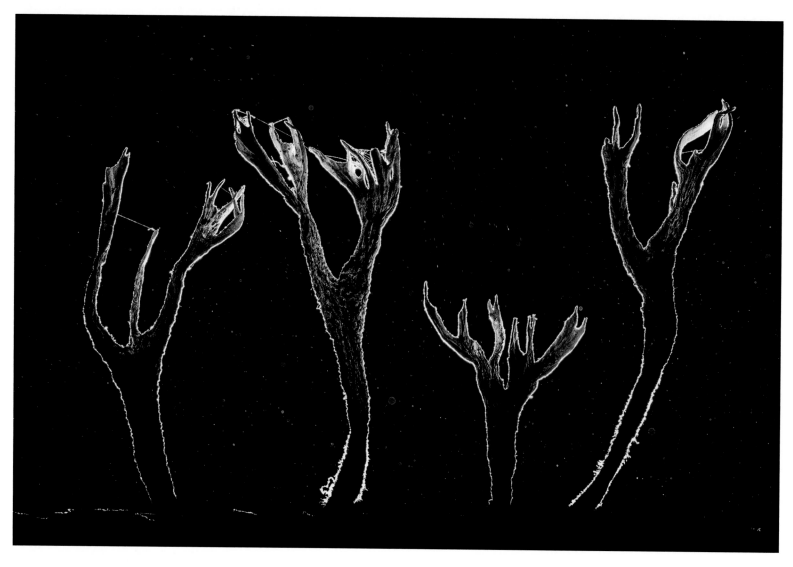

Dead-tree fungus
José Juan Hernández
SPAIN

Crouching down to look at the tiny growths, José was reminded of pictures he had seen of dead trees in the Namibian desert. But these were fungal fruiting bodies, just 4–5 centimetres tall (1½–2 inches), growing from a dead tree lying on the floor of the laurel forest in the misty mountains of Tenerife. The part they play in forest ecology is breaking down the cells of dead wood, leaving it soft for insects to feed on. Antler-like extensions give them the name stag's horn fungus. And the powdery white coating of spores that appears on the 'horns' in autumn and winter explains the alternative name candlesnuff (as in snuffed-out candle wick). These spores are asexual ones; later the fungus produces sexual spores but in lots of pockets on its black stem-like structure. José wanted to emphasize these dead-tree-like silhouettes. So he backlit the fungi, which also caused the suspended water droplets of the mist to refract the light and create the star-like backdrop.

Nikon D500 + 105mm f2.8 lens; 1/320 sec at f16; ISO 100; Speedlight SB-800 flash.

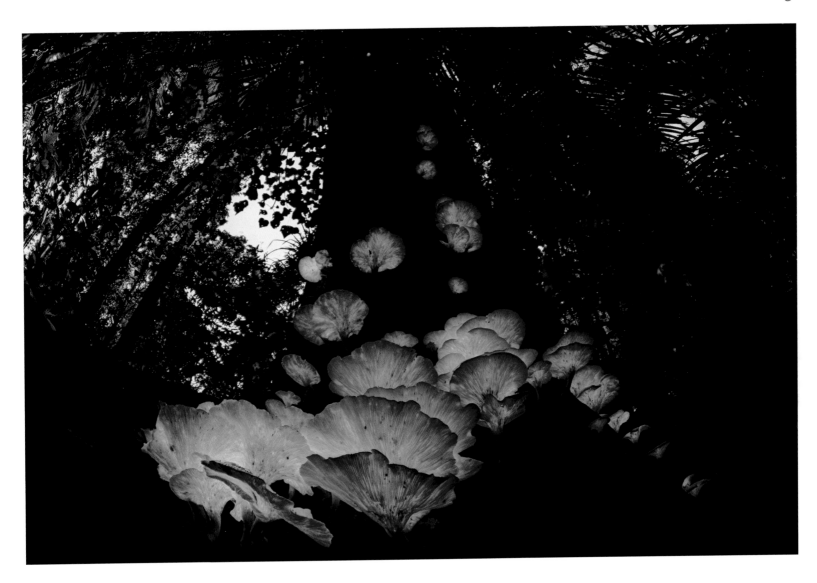

Mushroom magic
Juergen Freund
GERMANY/AUSTRALIA

It was on a summer night, at full moon, after monsoon rain, that Juergen found the ghost fungus, on a dead tree in the rainforest near his home in Queensland, Australia. He needed a torch to keep to the track, but every few metres he would switch it off to scan the dark for the ghostly glow. His reward was this cluster of hand-sized fruiting bodies. Comparatively few species of fungi are known to make light in this way, through a chemical reaction: luciferin oxidizing in contact with the enzyme luciferase. But why the ghost fungus glows is a mystery. No spore-dispersing insects seem to be attracted by the light, which is produced constantly and may just be a by-product of the fungi's metabolism. Juergen crouched on the forest floor for at least 90 minutes to take eight five-minute exposures – to capture the dim glow – at different focal points, which were merged (focus stacked), to create one sharp-focus image of the tree-trunk display.

Nikon D800E + 16mm f2.8 lens; 8 x 300 sec at f5.6; ISO 500; cable remote; ground tripod.

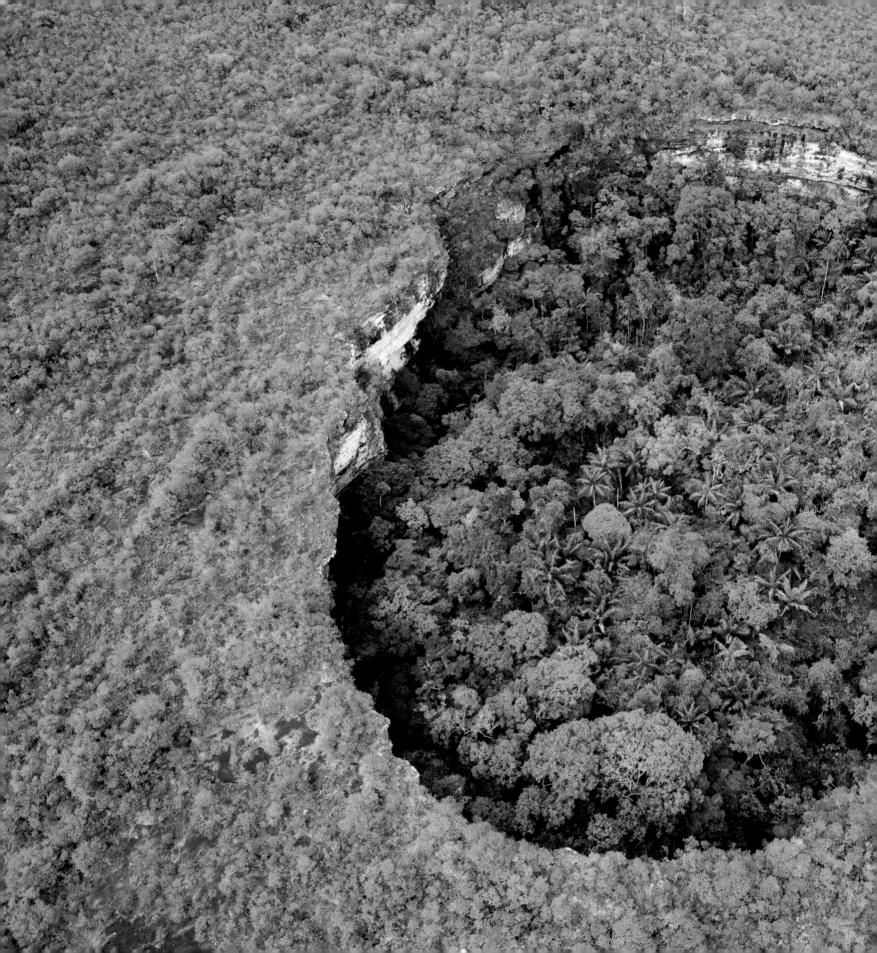

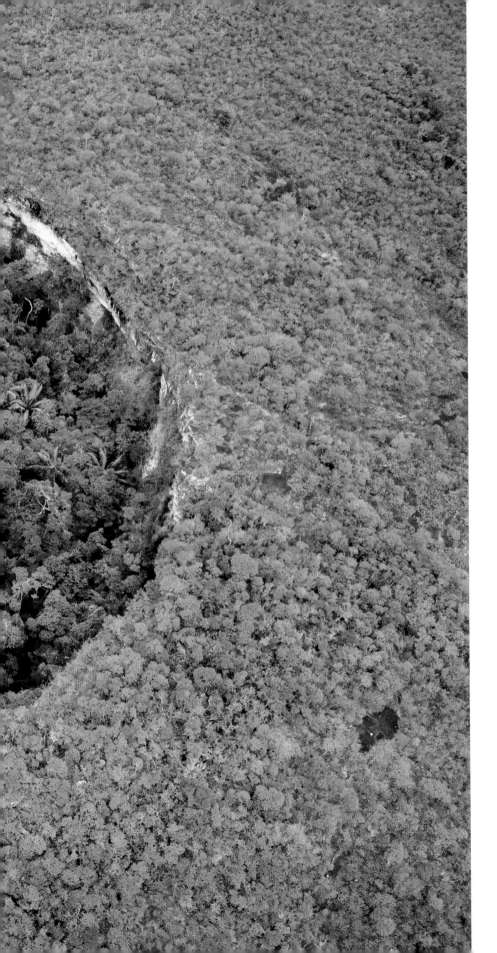

The fantastical rainforest
Daniel Rosengren
SWEDEN

Shooting through an open window, Daniel had to fight to hold his camera steady as the plane circled over the strange mountaintop cavern and its emerging rainforest. He was in the heart of Colombia's Amazon, in the Chiribiquete National Park – the world's largest tropical-rainforest park and a UNESCO World Heritage Site. His assignment was for an organization working to promote the riches of the park and help protect it from the encroachment of deforestation and gold-mining. The small plane had brought him to the outskirts of the park, from where he would have to explore on foot and by boat to document the park's extraordinary landscape and some of the many species of plants and animals that are found here and nowhere else. But first the plane gave him a chance to fly into the interior to photograph the giant rock outcrops of the park's tepuis – tabletop mountains – part of the Guiana Shield, cut through by rivers. Symbolic of the extraordinary nature of the 'Lost World' landscape was this tepui topped by a giant sinkhole. It was probably created when water erosion caused the sandstone roof of an enormous cave to collapse. Humidity within the cavern had allowed the development of a luxurious rainforest mix of broadleaf trees and palms, no doubt with a rich mix of epiphytic plants and associated animals, all undocumented. The frustration for Daniel was not being able to drop down into the green cavern and explore. In fact, much of the vast 4.2-million-hectare (10$^{1}/_{2}$-million-acre) park is a geographically isolated wilderness, biologically unexplored, with parts almost inaccessible. Even so, more than 2,000 plants have so far been recorded, with every expedition resulting in species new to science.

Nikon D800 + 24–70mm f2.8 lens; 1/2000 sec at f6.3; ISO 1000.

Wetlands:
The Bigger Picture

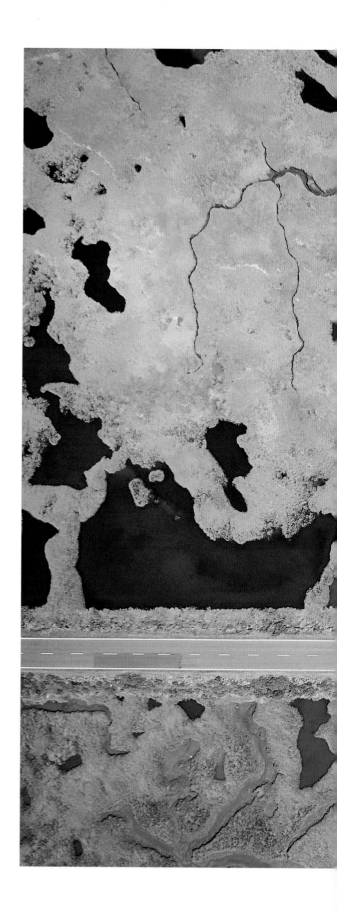

Road to ruin
Javier Lafuente
SPAIN

The stark, straight line of a tarmac road slices through the sinuous curves of the wetland landscape of the Odiel Marshes, a UNESCO Biosphere Reserve, the second largest wetland in southern Spain after Doñana (nearby) and Spain's most important tidal wetland. Here, near the Portuguese border, the mouths of the Odiel and Tinto rivers come together, creating a rich habitat of tidal marshes and lagoons. It's home to more than a hundred species of birds, including flamingos, spoonbills, hoopoes and black-winged stilts, with ospreys and bee-eaters among many migratory visitors. This road was constructed in the 1980s to provide access to a beach. It divides the wetland into two halves and affects the drainage. 'Was it worth it?' asks Javier, there being many other beaches in this region. The road also brings litter, pollution and disturbance to the wetland wildlife, which includes Iberian lynx and otters. Javier used a drone to create a series of aerial photographs of the marshes, carefully planning tide and light combinations, but aware that conditions are always changing. The challenge was to avoid the harsh sunlight reflected by the bodies of water. But by manoeuvring the drone and inclining the camera he succeeded in capturing the pools as flat colours, varying from deep blues to soft greens and ochre according to the vegetation and mineral content. The incongruous road, slicing through the tapestry of textures and colours, is framed as a symbol of how thoughtlessly we treat even the most precious of wetlands.

DJI Mavic 2 Pro + Hasselblad L1D-20c + 10.3mm f2.8 lens; 1/500 sec at f2.8 (+0.3 e/v); ISO 100.

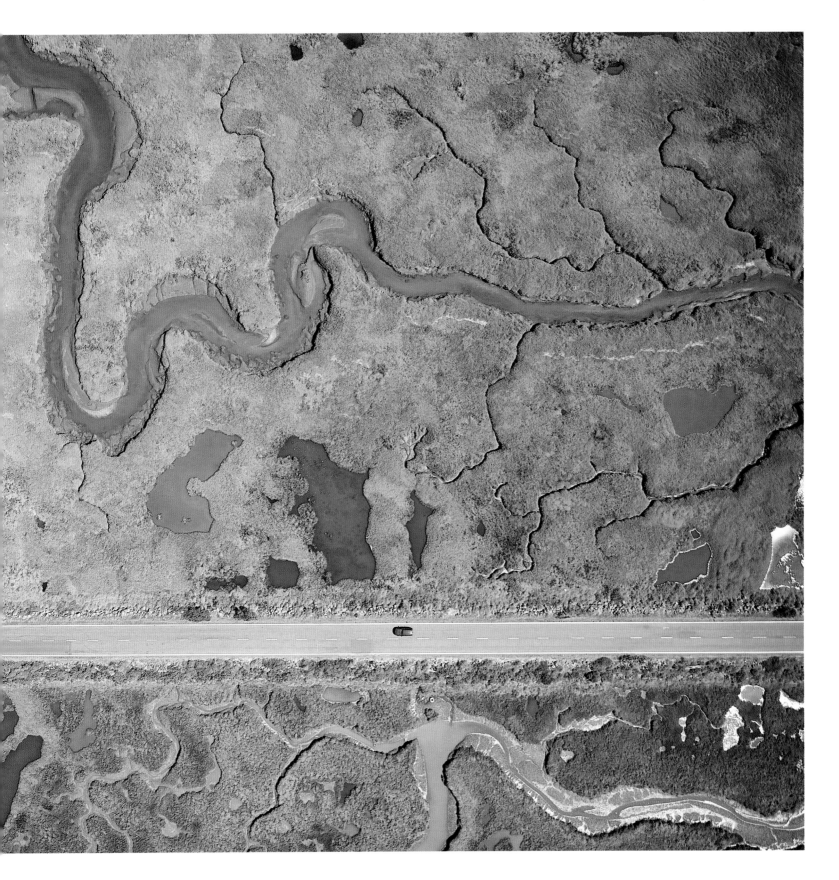

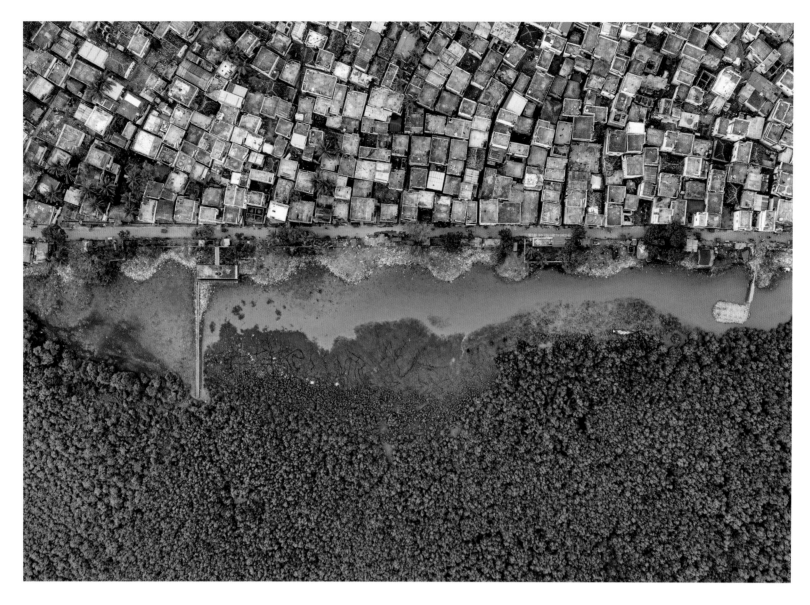

The nurturing wetland
Rakesh Pulapa
INDIA

Houses on the edge of Kakinada city reach the estuary, buffered from the sea by the remains of a mangrove swamp. Development has already destroyed 90 per cent of mangroves – salt-tolerant trees and shrubs – along this eastern coastal area of Andhra Pradesh, India. But mangroves are now recognized as vital for coastal life, human and non-human. Their roots trap organic matter, providing carbon storage, slow incoming tides, protect communities against storms and create nurseries for numerous fish and other species that fishing communities rely on. Flying his drone over the area, Rakesh could see the impact of human activities – pollution, plastic waste and mangrove clearance – but this picture seemed to sum up the protective, nurturing girdle that mangroves provide for such storm-prone tropical communities.

DJI Mavic 2 Pro; 1/80 sec at f3.2; ISO 200.

Turtle in paradise
Henley Spiers
UK/FRANCE

A turtle hides among waterlilies in the clear water of Aktun Ha cenote – once a cave and now a freshwater pool. There are thousands of cenotes in the limestone of Mexico's Yucatan Peninsula, linked through underground river systems that reach the ocean. Resident in Aktun Ha are fish, turtles and at least one crocodile. Henley was entranced by the turtle, so at home in the magical pool, its red markings echoing the red of the leaves. Only when looking at his pictures did he realize that the turtle was not a native Meso-American slider but probably a red-eared slider (native to the US and northeastern Mexico) – either a released pet or, more worrying, the offspring of one. These pets are now among the world's 100 most invasive species, interbreeding, altering freshwater habitats and carrying pathogens.

Nikon D850 + 8–15mm f3.5–4.5 lens; 1/160 sec at f10; ISO 640; Nauticam housing.

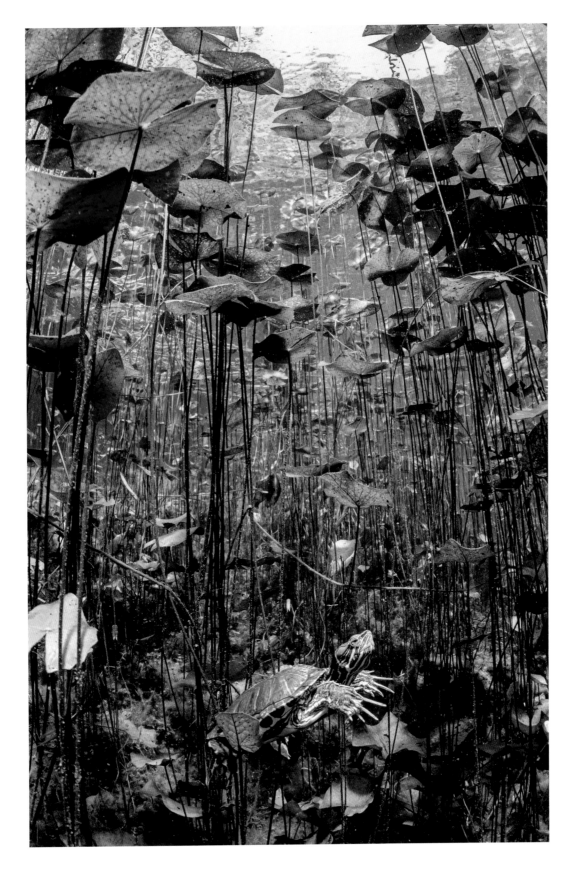

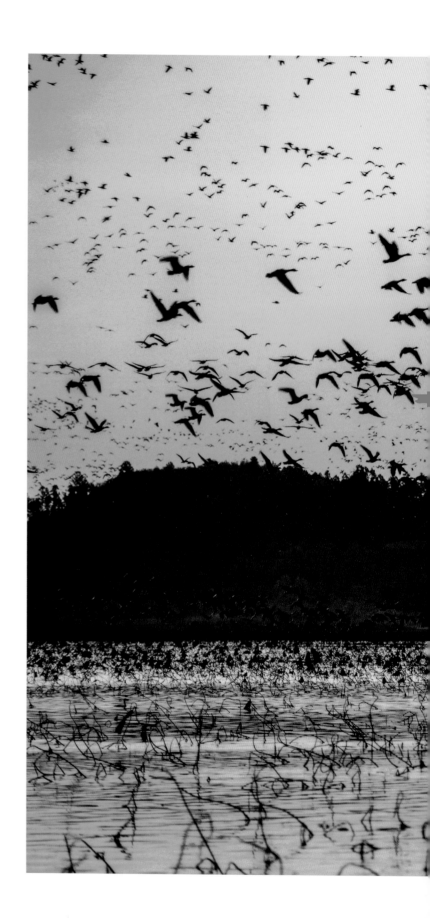

Uplifting dawn

Kazuaki Koseki

JAPAN

As dawn breaks over the Izunuma wetland in Japan, thousands of greater white-fronted geese take to the skies. After roosting overnight, they are leaving to forage on nearby paddy fields. These geese once ranged throughout Japan, but in the twentieth century, as land was claimed for food production, many wetlands were lost. The wetland surrounding lakes Izunuma and Uchinuma in northern Miyagi is nationally protected for its rich diversity of life. It is the largest wintering site in Japan for greater white-fronted geese, which fly 4,000 kilometres (2,485 miles) from their summer breeding grounds on the Arctic tundra. More than 100,000 of them overwinter in Izunuma and the surrounding area. By far the most abundant of 235 bird species recorded at the wetland, they are rapidly increasing in numbers – perhaps as a result of the earlier thawing of their Siberian breeding grounds, which allowed earlier and more successful breeding. It's an overconcentration at this one site that is starting to cause concern. Kazuaki has been photographing the geese here for five years. On this November day, hoping to capture the spectacle of an en masse take-off, he drove to Izunuma around midnight and waited until just before sunrise for enough light to capture what proved to be the biggest mass departure of the year. The colours evoke a tranquil scene, but to Kazuaki, the memory of the noise of wings and the barking and honking of thousands of families of geese echoing across the wetland makes this an image infused with invigorating, life-affirming sound.

Nikon D4S + AF-S 70–200mm f2.8 lens at 150mm; 1/200 sec at f4 ; ISO 400.

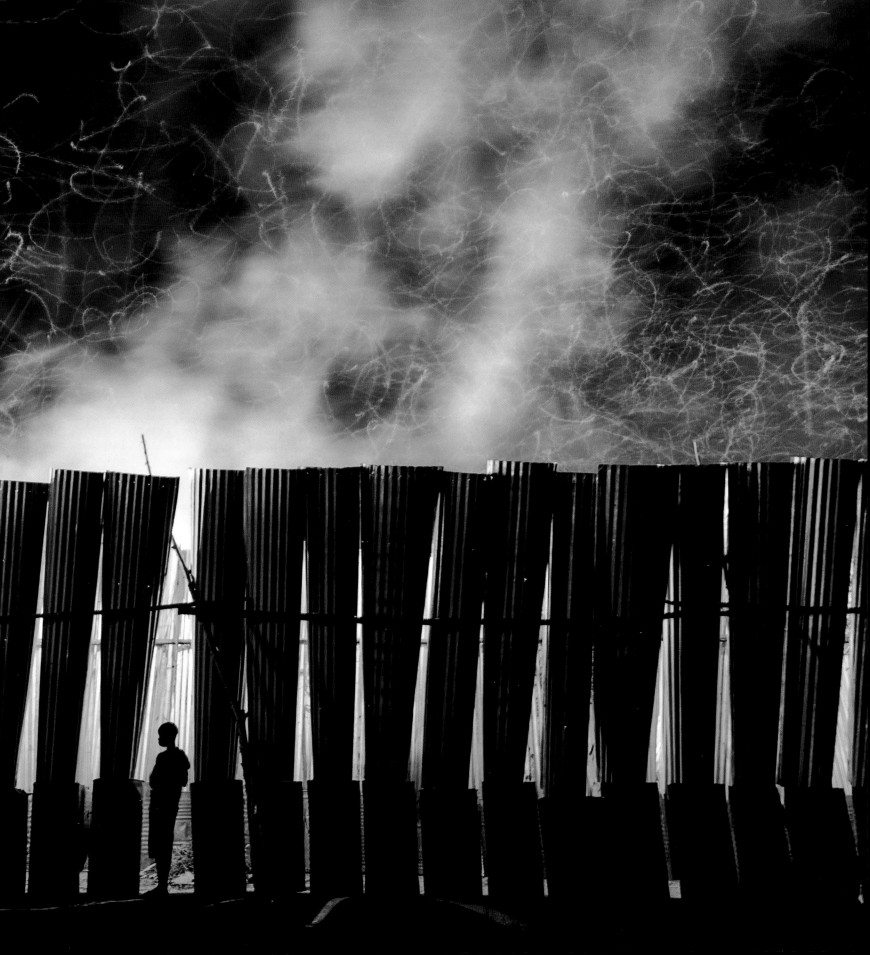

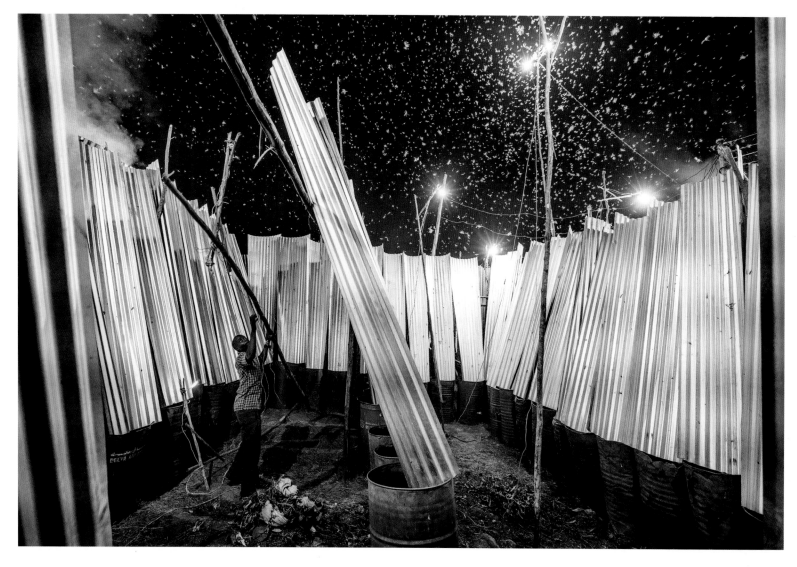

Trap-setting

A man works to replace one of the three mercury halogen lamps erected on sticks in his *nsenene* trap – made up of metal sheets angled into oil drums and arranged in a room shape. Hooked up to electrical-current 'drivers', these 400W lights have their output amplified to 1200W, which means the bulbs may only last a week. But nowadays the catching period can also be relatively short. On the night of this photograph, the swarms of bush crickets had flown over and disappeared into the night in less than an hour. Though increasing the power of the lights increases the catch, there is a risk for the trapper from ultraviolet-C radiation. Even the slightest visual contact causes eye irritation, and exposure over time can result in cataracts and even skin cancer. Large commercial catches, combined with the destruction of the bush crickets' feeding and breeding grounds, are also a risk to the *nsenene* business itself.

Canon EOS R + 16–35mm f2.8 III lens; 1/125 sec at f4 (+0.3 e/v); ISO 1600.

Drum catch

In the oil-drum collection end of a *nsenene* trap are the evening's catch of bush crickets. Stunned by hitting the metal sheets and sedated by smoke from burning grass, only a few manage to escape by climbing the oily inside of the drum. The bush crickets are cryptically coloured, matching some of their grass food plants. Bright green and straw brown are the most common colour forms. Females and males (identifiable by their longer antennae) are caught indiscriminately, and sometimes non-target insects are attracted to the lights, including moths and toxic beetles that may contaminate the catch. In the 1990s, when the light traps were first used in Masaka, the drums would fill up quickly. Now, by the end of the night, the drums are more likely to be half empty. The decline in the *nsenene* catch is linked to the destruction of the wetland grasslands where the bush crickets lay their eggs. Near Masaka, rice fields, sand mines and construction projects have gradually encroached on the surrounding grasslands and wetlands, and in Uganda as a whole, the destruction of feeding and breeding habitat may be as much as 40 per cent.

Leica SL + 16–35mm lens; 1/40 sec at f16 (-3 e/v); ISO 1600; Profoto B10 flash.

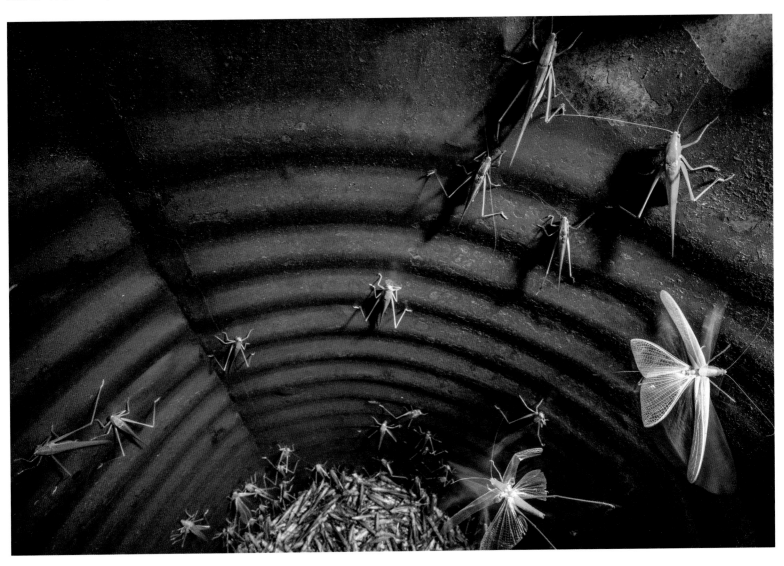

The market for nsenene

At sunrise, at the Katwe Market in the Ugandan capital of Kampala – the largest wholesale market for *nsenene* – sacks of freshly caught, live bush crickets are offloaded for sale to market vendors and to customers wanting them for home cooking. Rich in protein and healthy fatty acids, *nsenene* is regarded by Ugandans as a nutritious, high-quality food and a tasty snack, and demand is high. Two hours later, the market will be full of customers buying ready-to-eat *nsenene*, which stall-holders sell boiled or deep-fried.

Canon EOS R + 24–105mm f4 lens; 1/250 sec at f11 (-0.3 e/v); ISO 3200.

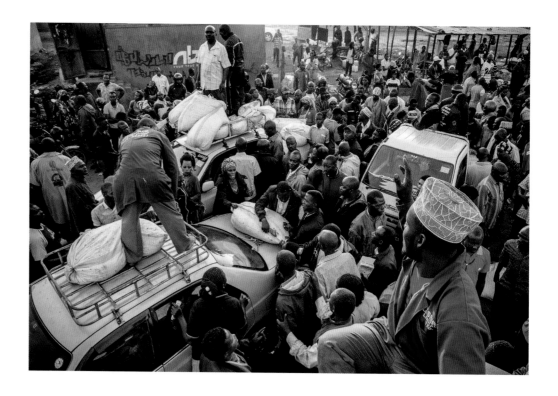

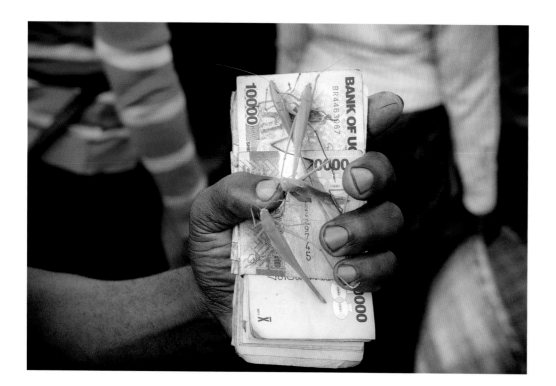

Insect cash

Putting some bush crickets on his stash of cash, a buyer proudly confirms that *nsenene* is big business in Uganda. Whether through trapping or market sales, the biannual catch of bush crickets now provides a vital income to a growing number of Ugandans. But changing weather patterns and the destruction of the bush cricket's habitat is making it more difficult for competing trappers to make a profit. This also signals the unsustainable nature of *nsenene* trapping as a business.

Canon EOS R + 24–105mm f4 lens; 1/160 sec at f11 (+0.7 e/v); ISO 2500.

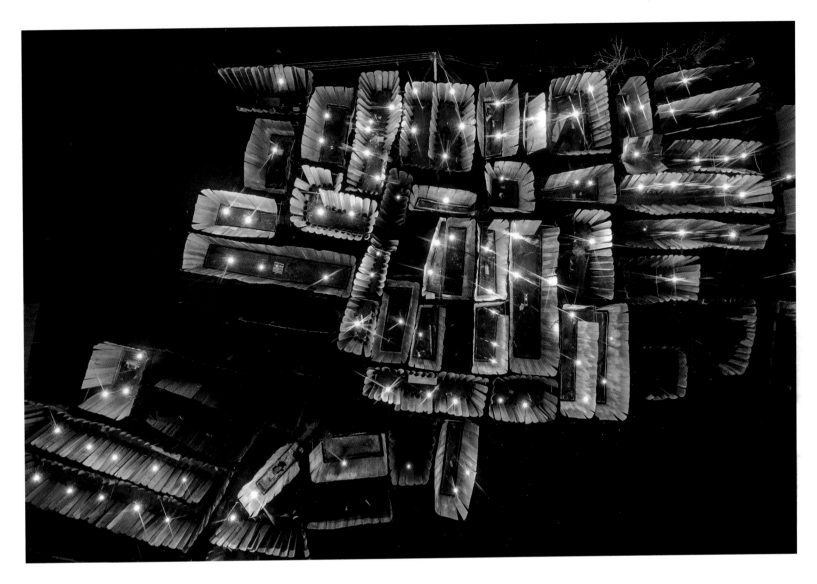

A swarm of traps

A drone view of a collaboration of individual *nsenene* traps. The trappers have discovered that the increased brightness and heat from their combined lights increases the arriving swarms of bush crickets. But in recent years, that has stopped happening, and there has been a big decline in the catch. The arrival of *nsenene* twice a year, every May and November, has been regarded like the rains, as a gift from the heavens. What the trappers may not have realized is that the habitat where the bush crickets breed is being destroyed, or that, when they are collected in their thousands, egg-laying females included, the next generation is reduced. Changing weather patterns could also be contributing to the decline, whether through drought, caused by deforestation and grass clearance, or by heavy rains flooding the shores of Lake Victoria, where the insects breed. Currently, Ugandan scientists are trying to find ways to mass-produce bush crickets – to take the pressure off the wild ones – but the cost of commercially farmed insects could make them unaffordable to ordinary Ugandans.

DJI Phantom 4; 1/40 sec at f2.8; ISO 400.

Photojournalism

Elephant in the room
Adam Oswell
AUSTRALIA

Zoo visitors watch with obvious fascination and take pictures as a young Asian elephant performs under water. For the photographer, the scene was a disturbing one, the audience seemingly oblivious of the exploitation involved and signs of the elephant's distress. It's part of a daily show in Khao Kheow Open Zoo, Thailand, involving elephants being forced to swim, 'dance' and do tricks. The zoo promotes it as an educational show and exercise for the elephants. But organizations concerned with the welfare of captive elephants view the spectacle as exploitative, with performers cajoled to stay under the water and walk on two legs. They also point out that the training of an elephant starts with the removal of a calf from its mother and traditionally uses fear- and pain-based punishment. The wider issue, though, is the growth of elephant tourism. The low birth rate of elephants in captivity, coupled with the demand for calves, has incentivized the poaching of wild-born young, including ones from across the border in Myanmar. Though elephant use, whether for logging or transport, has been part of Thai culture for centuries, in the past three decades, international tourism has increased so much that, in Thailand, there are now more captive elephants (possibly 3,800) than wild ones (fewer than 3,600). It started when logging was banned in 1989, forcing the owners of logging elephants to turn to tourism for income. Animal-welfare legislation has theoretically made aspects of elephant tourism illegal, but only if enforced, and standards for elephant tourist camps are needed, alongside elephant registration. But in 2020, tourism was brought to a sudden halt by Covid-19. Without income, owners have struggled to feed their elephants, and sanctuaries have been overwhelmed by abandoned animals. The hope is that, as tourism returns, there will be a tightening of regulations and increased education of owners and tourists to ensure that captive elephants are treated with respect and kindness, and that no more young ones are taken from the wild.

Nikon D810 + 24–70mm lens; 1/640 sec at f2.8; ISO 1250.

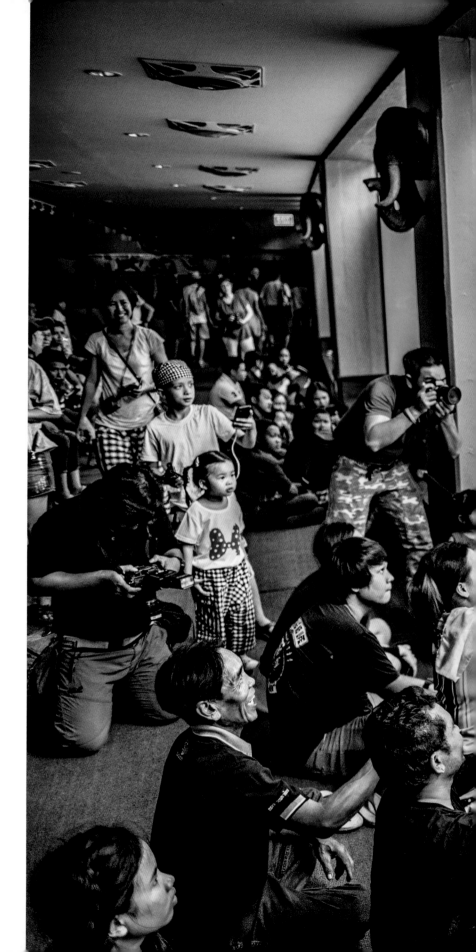

Endangered trinkets
Bruno D'Amicis

ITALY

A villager offers endangered Cuban land snail shells and necklaces for sale from her home near Baracoa, Cuba. These vibrant spirals are the empty remains of *Polymita picta*, the largest of six *Polymita* species, also known as painted snails. All are endemic and found almost exclusively in the thin belt of vegetation running along the easternmost Cuban coast and towards the mountains. Slow-moving and picky, they mostly eat algae and lichens scraped off the leaves of particular tree species, and they are vulnerable to habitat loss, pollution, climate breakdown and predators such as introduced rats. Trade in their shells is illegal, but their appeal and rarity fuel demand. The sale of just one handful to a tourist would make a material difference to the vendor, and on the international collectors' market could fetch what in Cuba is a small fortune. Alongside habitat protection and law enforcement, say local conservationists, raising awareness will be key in averting their extinction.

Canon EOS 5D Mark IV + 24–70mm f2.8 lens at 28mm; 1/50 sec at f5.6; ISO 800.

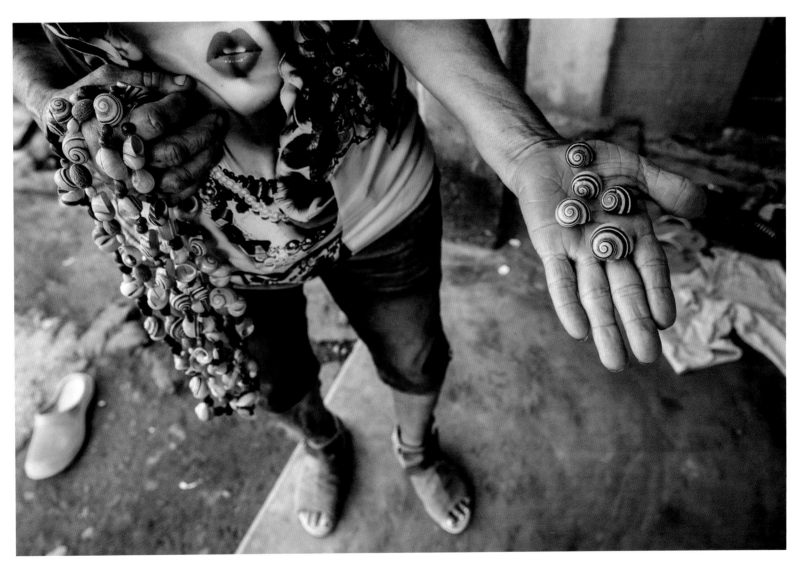

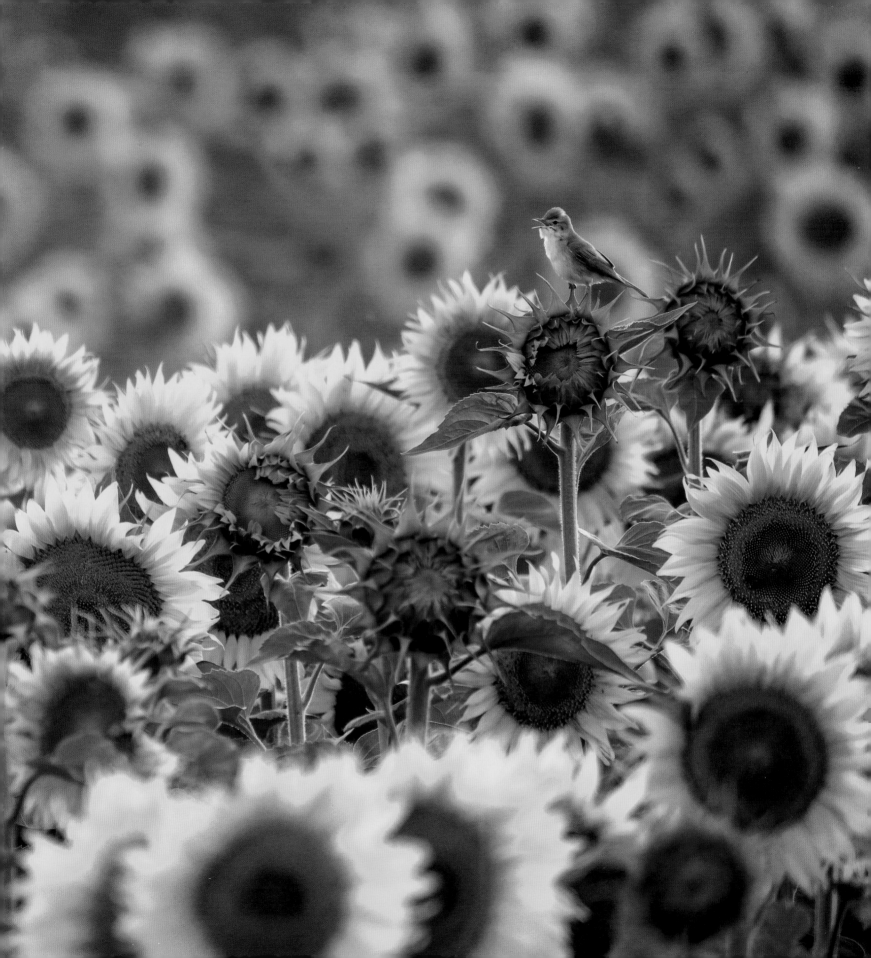

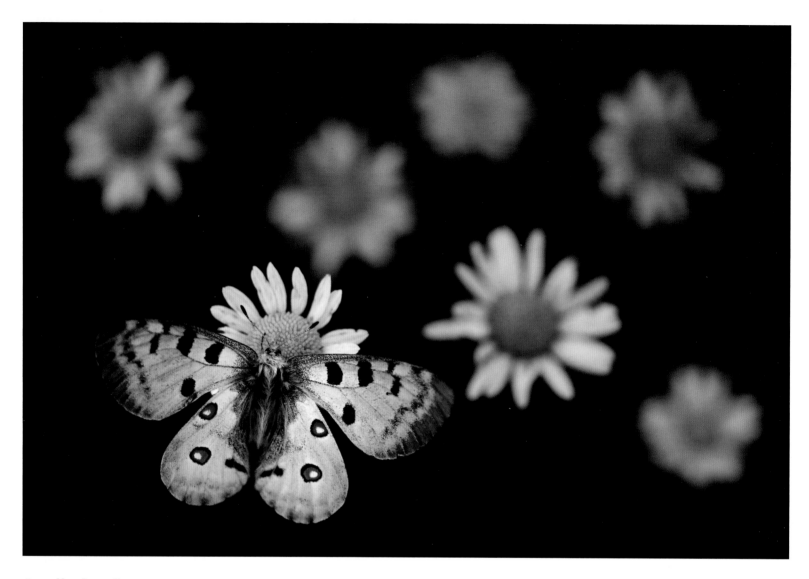

Apollo landing

Emelin Dupieux

FRANCE

As dusk starts to fall, an Apollo butterfly settles on an oxeye daisy. Emelin had long dreamed of photographing the Apollo, a large mountain butterfly with a wingspan up to 90 millimetres (3$^1/_2$ inches) and now one of Europe's threatened butterflies, at risk from the warming climate and extreme weather events. In summer, on holiday in the Haut-Jura Regional Nature Park, on the French-Swiss border, Emelin found himself surrounded by alpine meadows full of butterflies, including Apollos. Though slow flyers, the Apollos were constantly on the move. The solution was this roost, in a woodland clearing, where the butterflies were settling. But a breeze meant the daisies were moving. Also the light was fading. After numerous adjustments of settings and focus, Emelin finally achieved his emblematic image, the whites standing out in stark contrast, and just daubs of colour – the yellow hearts of the daisies and the red eyespots of the Apollo.

Nikon D7500 + Sigma 105mm f2.8 lens; 1/1000 sec at f3.2 (-1.7 e/v); ISO 1000.